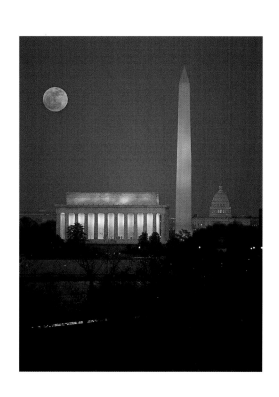

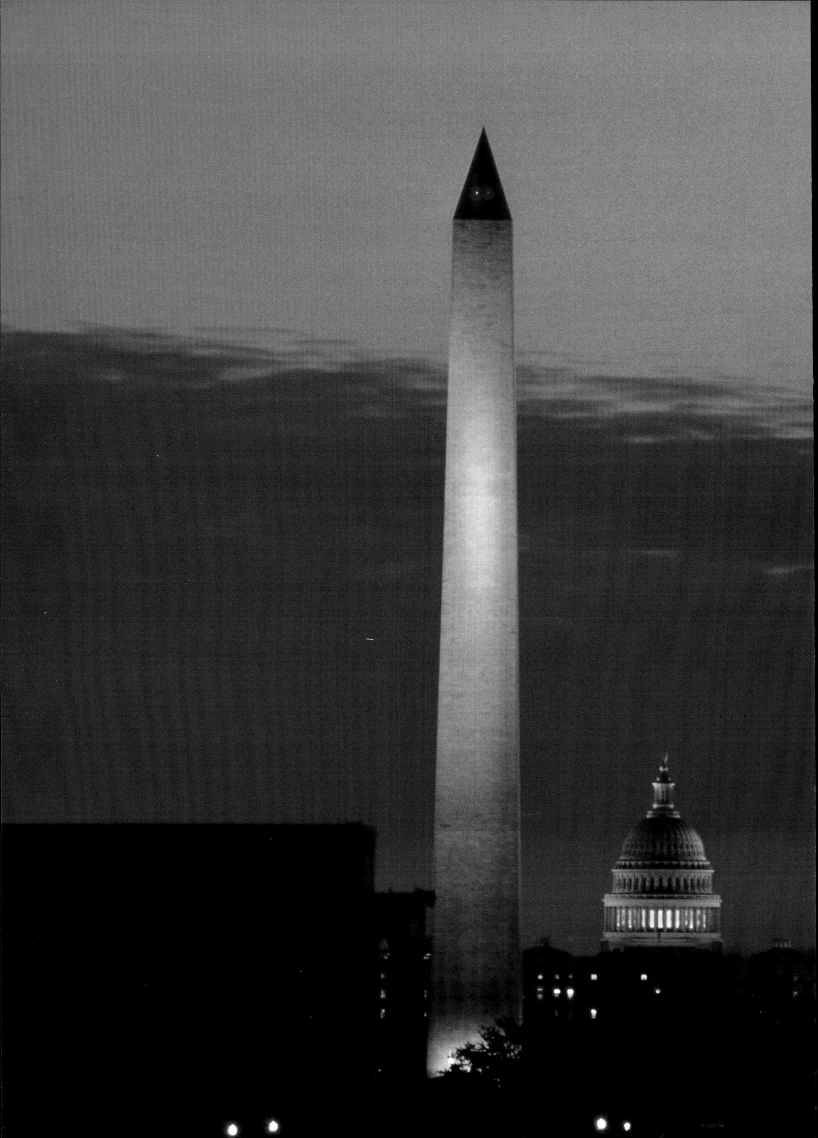

WASHINGTON, D.C.

A PHOTOGRAPHIC CELEBRATION

COURAGE BOOKS

AN IMPRINT OF RUNNING PRESS
PHILADELPHIA • LONDON

19 18 17 16 15 14 13 12 11 10
Digit on the right indicates the number of this printing

Library of Congress Cataloging-in-Publication Number 97-066806

ISBN 0-7624-0285-7

Designed by Frances J. Soo Ping Chow
Typography: Felix and Adobe Caslon

Published by Courage Books, an imprint of
Running Press Book Publishers
125 South Twenty-second Street
Philadelphia, Pennsylvania 19103-4399

(half title page) Full moon rising over the Lincoln Memorial, Washington Monument and the U. S. Capitol Building from Iwo Jima Memorial.

(title page) U.S. Capitol and Washington Monument at sunset.

UNLIKE MOST CITIES, which develop spontaneously over hundreds—even thousands—of years in response to such natural phenomena as navigable rivers, safe harbors, and drinkable water, Washington, D.C. was an entirely planned city set down in a location whose geography immediately rendered it controversial. Two rivers, the Potomac and the Anacostia, provided great opportunities for commerce, but much of the ground between them was marshy, mosquito-infested swamp. Sparsely populated, the site of the future "federal city" struck some early visitors as hopelessly desolate. Others, however, saw its green hills and bountiful rivers as tremendous assets.

The concept of a capital city inspired political debate. Several states lobbied for the presence of the capital within their borders, necessitating the creation of a neutral site for the seat of the new federal government. At the same time, another controversy raged in Congress concerning the introduction of a bill that would authorize the federal government to assume the Revolutionary War debts of the individual states. While popular in the north, the bill was particularly disliked in the south. Indeed, opposition was so strong that it threatened to destroy the union. To settle the issue, Thomas Jefferson brokered the compromise of 1790, by which a few opposing congressmen agreed to change their votes in exchange for a southern location for the capital. Thus began Washington, D.C., a city born of compromise.

For the look of the capital, Thomas Jefferson favored a Greco-Roman model. Pierre L'Enfant, the French engineer hired by George Washington to design the plans for the city, preferred something more like Versailles. Both agreed, however, that the city should be grand, with broad avenues, public parks, and magnificent buildings to equal those found in European capitals. In the early years of building, however, the reality was quite different. A few houses were scattered here and there amid the 100-square-mile site. Existing roads were unpaved and muddy after a rain.

While Washington's rugged qualities often filled sophisticated travelers with dismay, others looked on the growing city with favor, seeing in it a magnificent enterprise with immense potential for greatness. Pierre L'Enfant was one such visionary. Temperamental and inflexible, he created a plan for the city that has been debated ever since its conception. After dividing Washington into four quadrants, L'Enfant superimposed diagonal avenues over the east-west and north-south street grid created by the

commission charged with overseeing construction of the city. L'Enfant's plan caused little confusion at first because there were so few buildings and even fewer streets. Today, however, this "chessboard overlaid with a wagon wheel" confounds pedestrians and motorists alike. To further complicate matters, government buildings and property frequently interrupt the flow of the street. Pennsylvania Avenue disappears at the Capitol and again at the White House, for example.

The quadrant system poses another complication as well. Because most streets and avenues stretch through more than one quadrant, a directional suffix is an integral part of each address. For example, the intersection of E and 6th streets occurs in each of the four quadrants—SW, NW, NE, and SE—causing all kinds of confusion. Without the suffix, mail cannot be delivered properly—and newcomers get lost.

Most of the buildings and monuments for which Washington is famous can be found in the northwest quadrant. The White House, the most famous building in Washington, if not the world, is located up on a hill, on Pennsylvania Avenue. From the White House, one can see the Washington Monument and the Thomas Jefferson Memorial.

Pierre L'Enfant created the first design of the President's House or Palace, as the White House was originally called. George Washington gave his approval to the plan, but eventually was forced to fire L'Enfant after the French engineer destroyed the house of a prominent Washington civilian. Thomas Jefferson then persuaded Washington to hold a competition for the design of the White House, a competition which he, Jefferson, anonymously entered. However, Jefferson's design did not win. In fact, President Washington was so unimpressed by the contest entries that he sought out James Hoban, a young Irish-born American architect he had met several years earlier. It is no surprise that Hoban won the competition.

Although President Washington participated heavily in the design and construction of the White House he never lived there as his second term of office expired before the building's completion. John Adams and his wife Abigail were the first occupants of the White House, whose interior design matched the rustic nature of the city itself. The White House decor became more sophisticated under Thomas Jefferson's stewardship. Sadly, when the British burned the White House and everything in Washington during the War of 1812 all of the progress was undone. Presidents Madison and Monroe oversaw the reconstruction of the White House, which has been periodically renovated ever since.

But it isn't only the history of the White House that intrigues us so much—the lives of its occupants are fascinating. We wonder what it is like to live in such a large and public place. We marvel at the pomp and circumstance surrounding White House ceremonies and state dinners. We enjoy the antics of presidential children and pets.

Life in the White House has changed dramatically over the years. The flexibility and freedom that our early presidents knew has been replaced by concrete anti-terrorist barriers and Secret Service agents offering round the clock protection. No longer can presidents skinny dip in the Potomac as did President John Quincy Adams. No longer can First Ladies hold open houses for the entire Washington, D.C. population. No longer can presidential children keep their cows and ponies on the White House grounds. But certain things have remained the same. The Easter Egg Roll continues year after year. The White House is still open to the public day after day. And once every four or eight years the president and the president-elect engage in the world's most peaceful transfer of power.

Washington, of course, boasts other significant buildings and monuments. The U.S. Capitol and the Supreme Court constitute the city's other branches of power and are architectural masterpieces in their own right. The National Cathedral is an impressive example of 20th-century masonry. The Library of Congress possesses an elegant reading room, fitting for the nation's capital. Likewise, the city's many monuments are magnificent works of art. From Washington to Jefferson to Lincoln, from the Civil War to Korea to Vietnam, Washington's monuments commemorate the most important people and events in the history of our nation.

Perhaps that history is what is most remarkable about Washington, D.C. When our founding fathers were creating a new form of government, they created the federal city of Washington to serve as a symbol of that government, a government of the people, by the people, and for the people. The streets they built, the buildings they constructed, and the institutions they created serve as physical symbols of their commitment to the ideals that created our democracy. In Washington, D.C., we can read the words of Jefferson and Lincoln in the monuments built to honor them; there we can read a list of names on a stark black wall or stare at a statue of soldiers hoisting the American flag on a battlefield; there we can pay homage to the American spirit that created a country—and a capital city—out of wilderness.

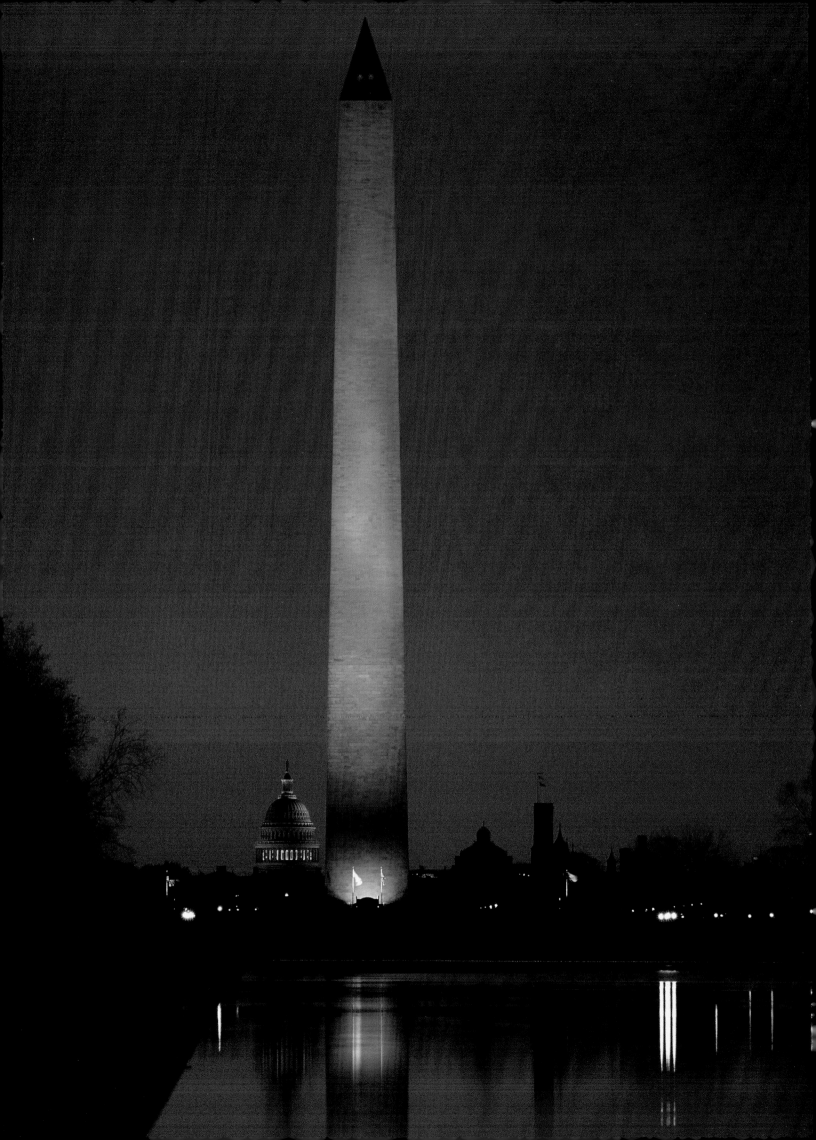

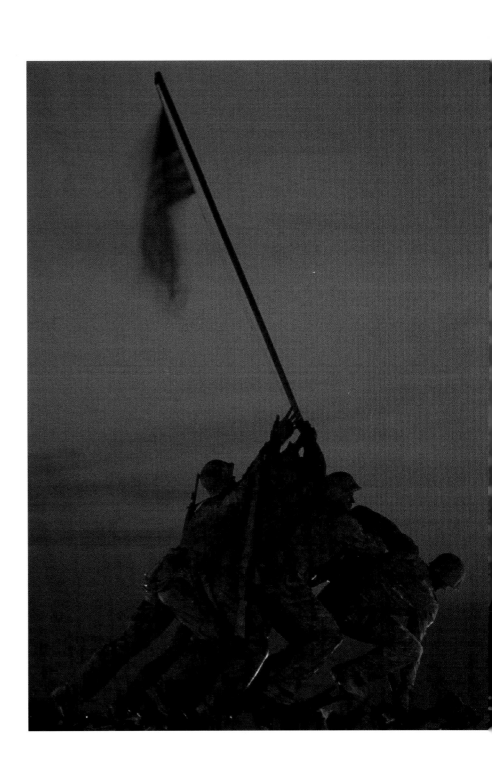

9 **(left)** National Mall. **(top)** Iwo Jima Memorial.

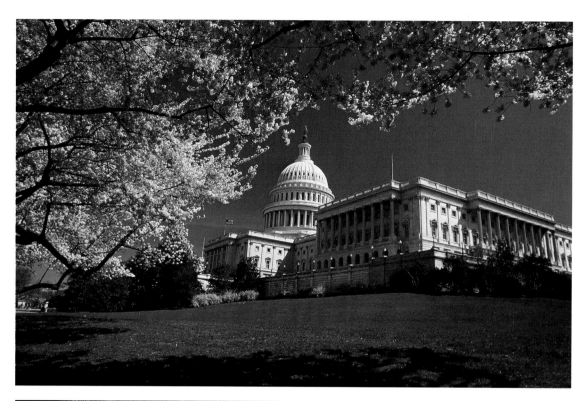

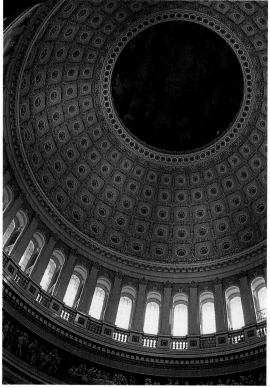

I found myself walking over to the Capitol and into the Rotunda. While I was looking around, some tourists were enjoying the feeling that the building belonged to them. Only in America, I thought, would the citizens be so unafraid of their governmental seat and so genuinely eager to drop in and look around."

William Zinsser
20th-century American writer

(top) The Capitol. (bottom) The Rotunda. (right) The Capitol and The Mall at night.

(overleaf) The west side of the Capitol overlooks the Capitol Reflecting Pool and the Grant Memorial.

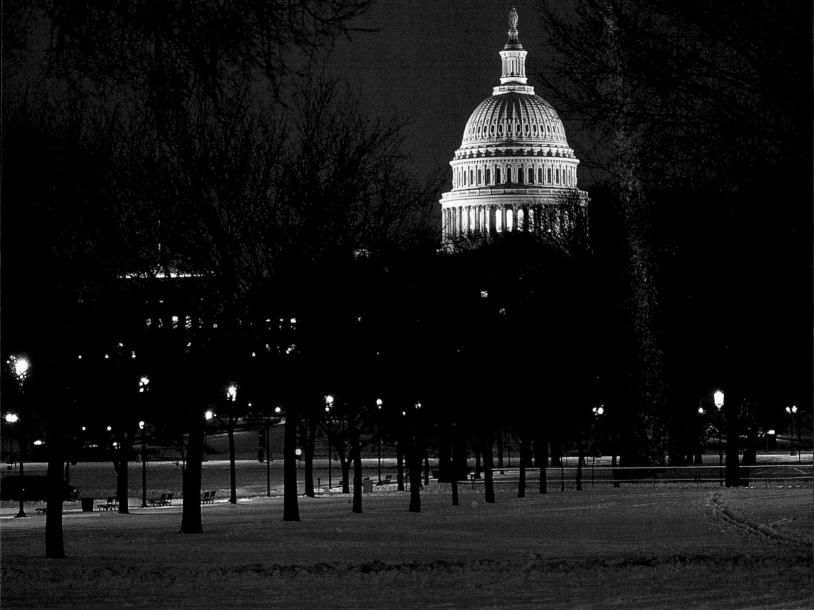

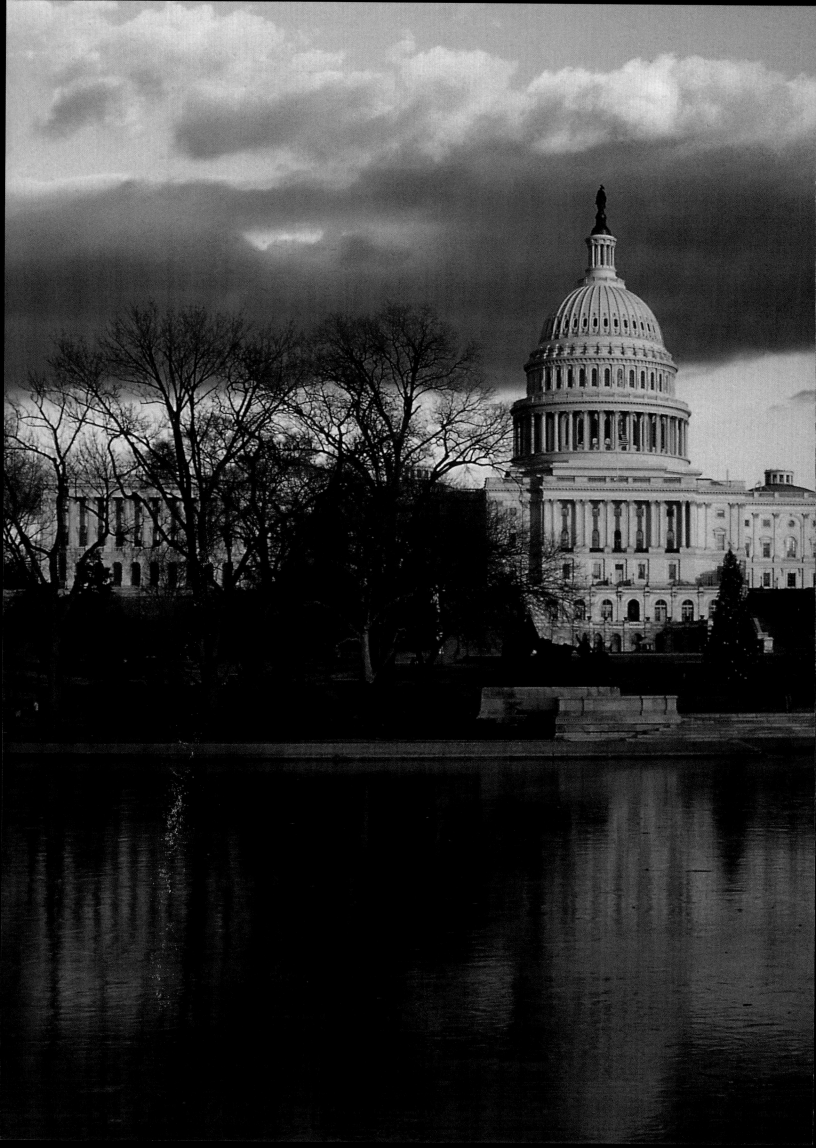

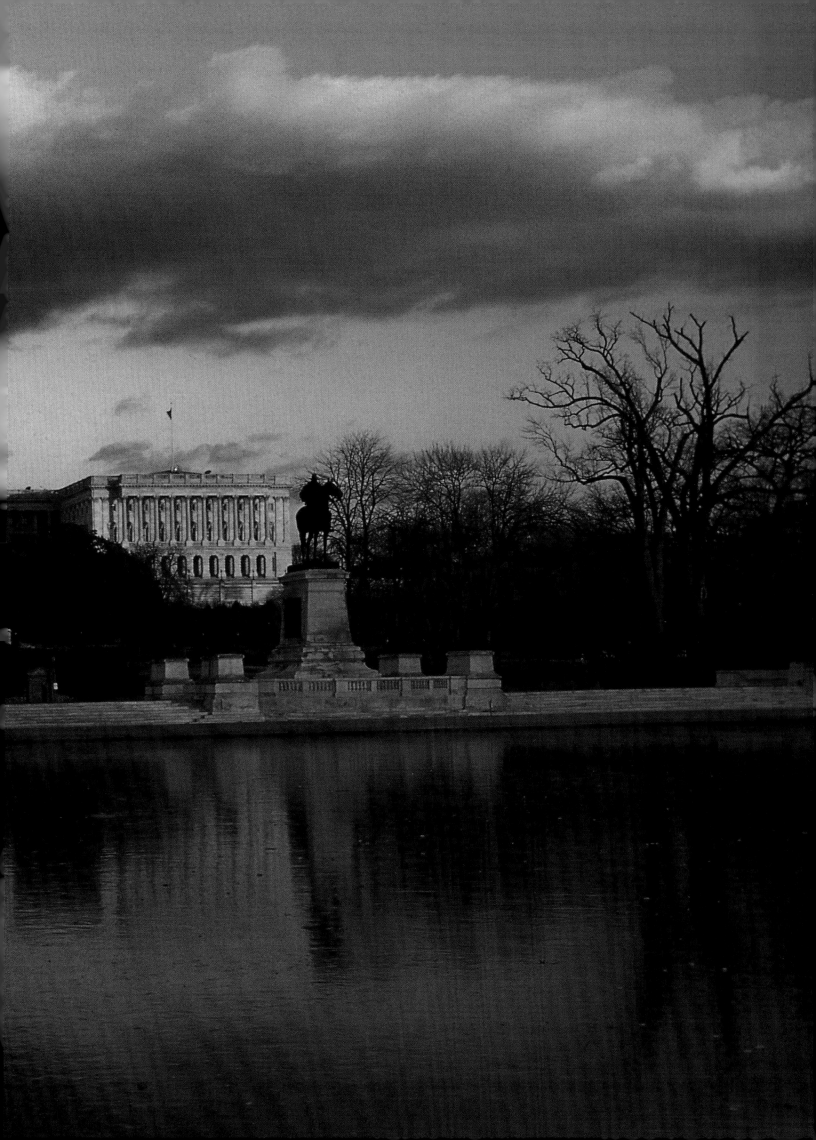

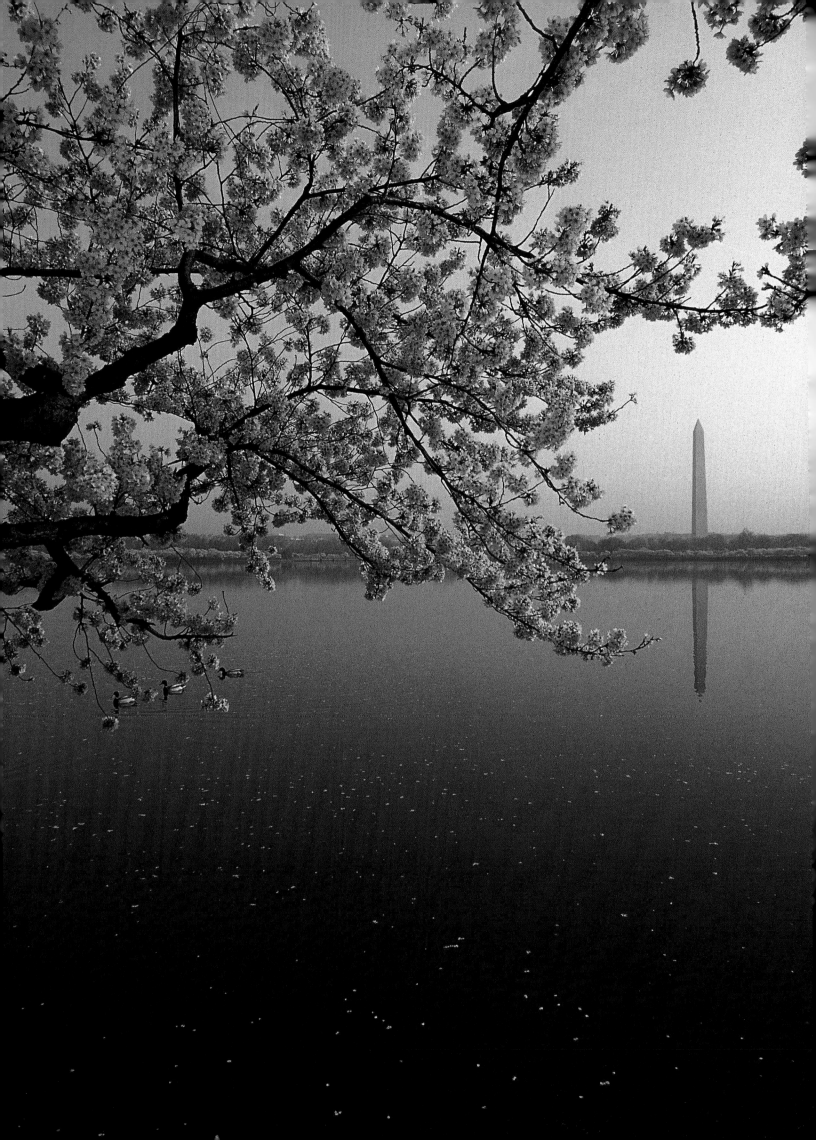

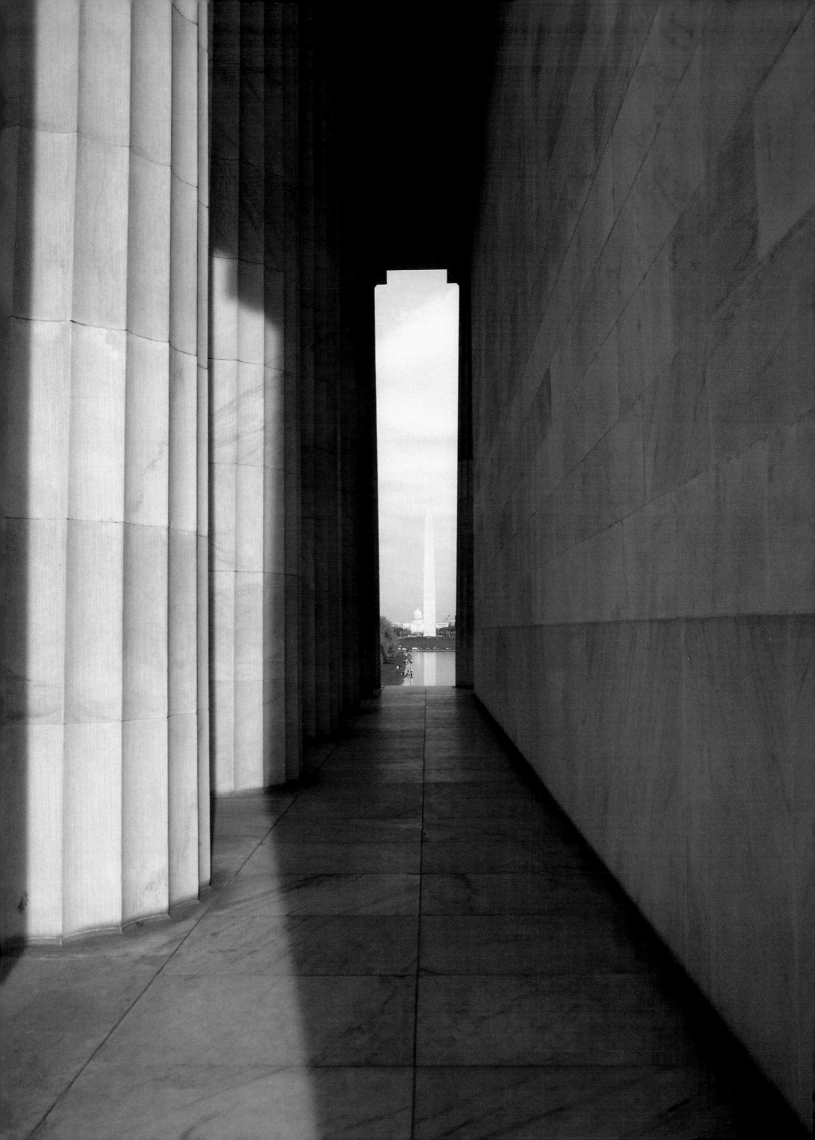

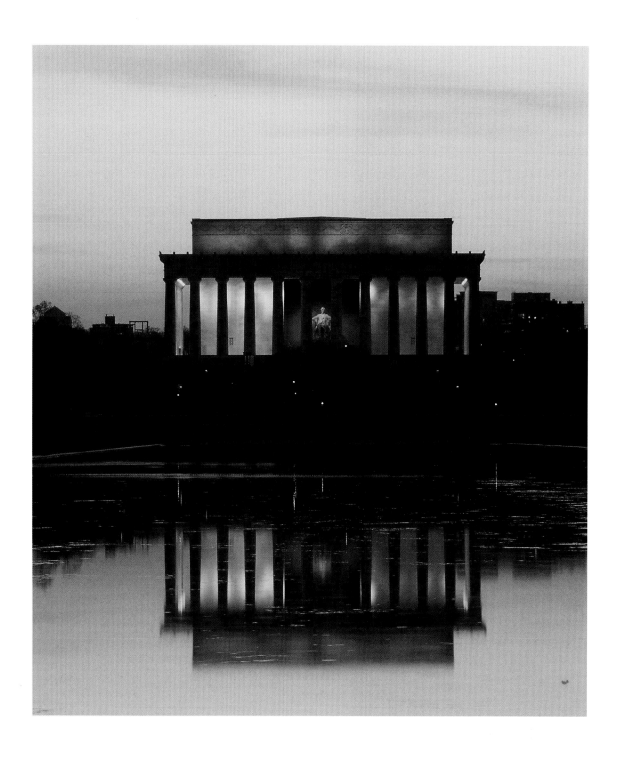

(previous page) The Washington Monument and Japanese cherry trees lining the Tidal Basin frame the Washington Monument as seen through the Lincoln Memorial.

(above and right) The Lincoln Memorial. *"In this temple as in the hearts of the people for whom he saved the union the memory of Abraham Lincoln is enshrined forever."*

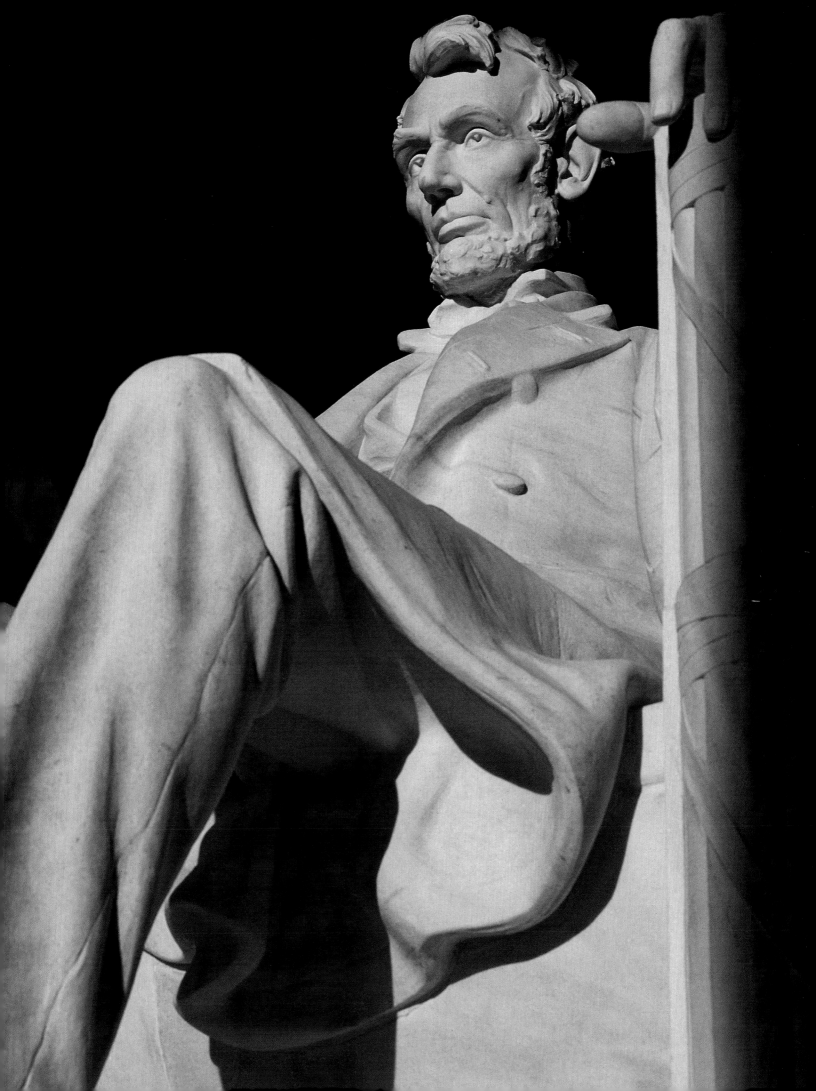

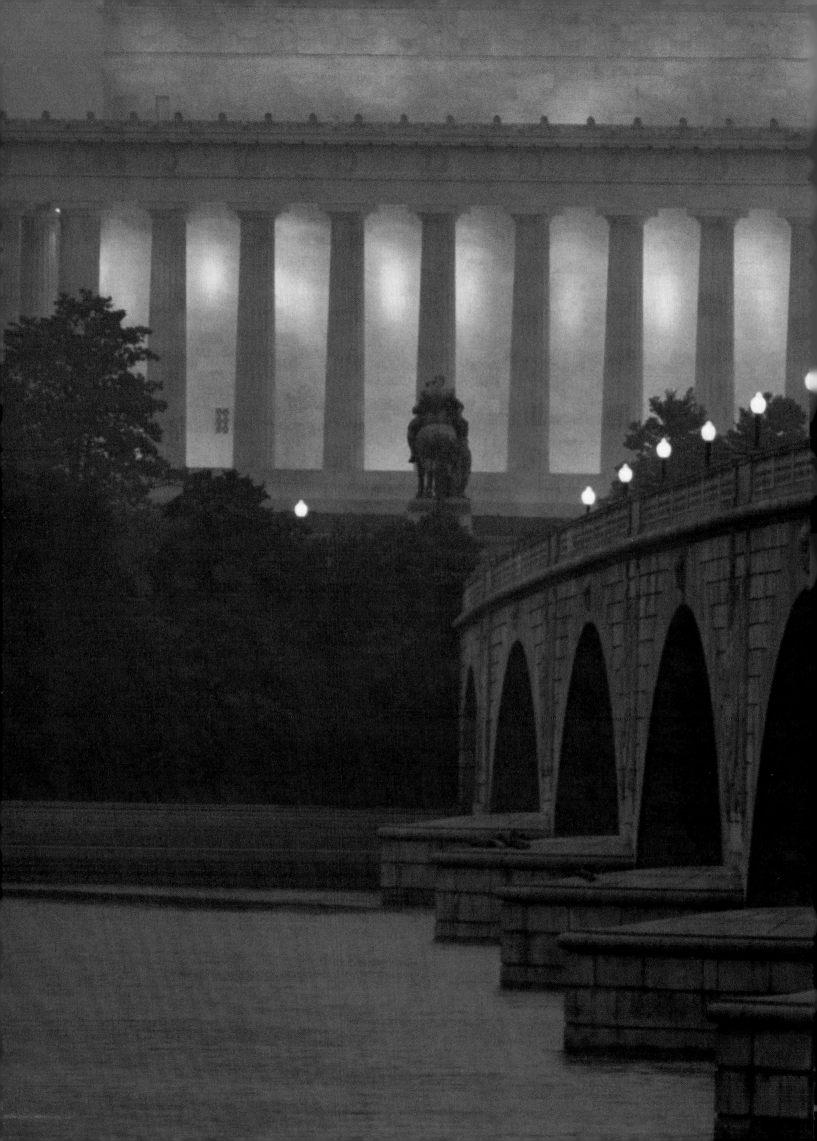

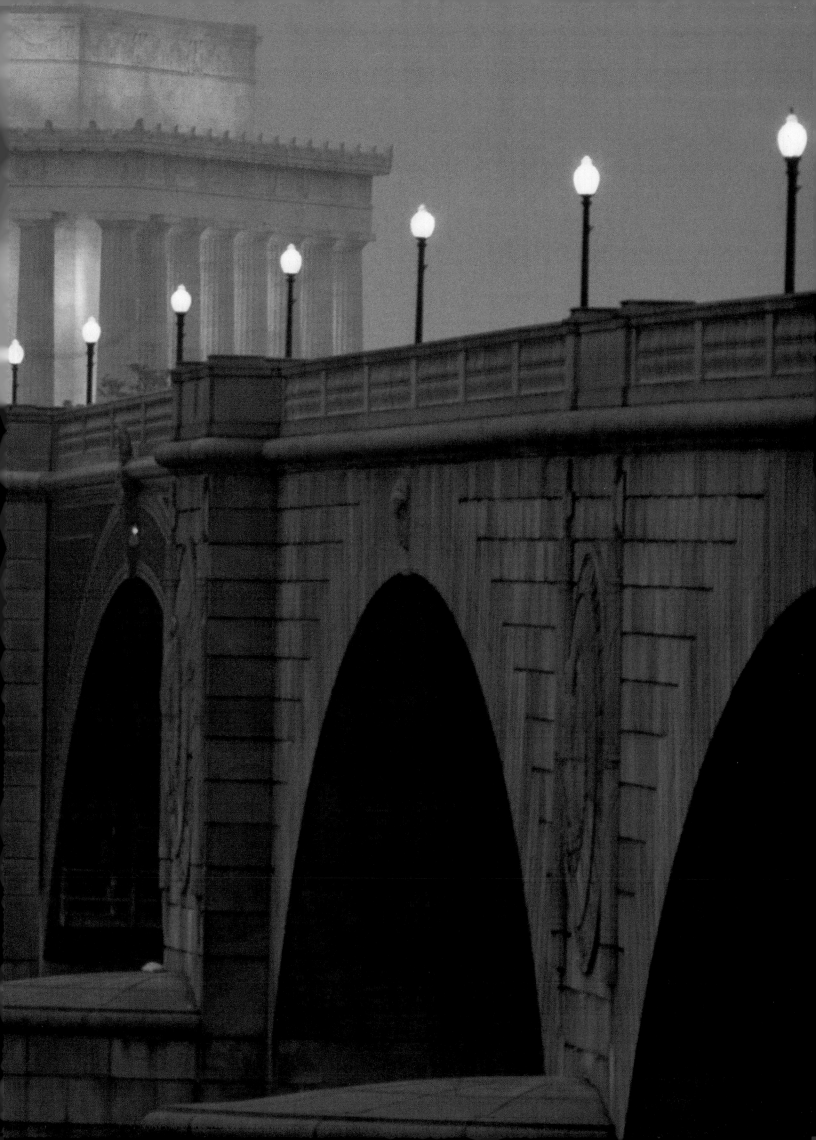

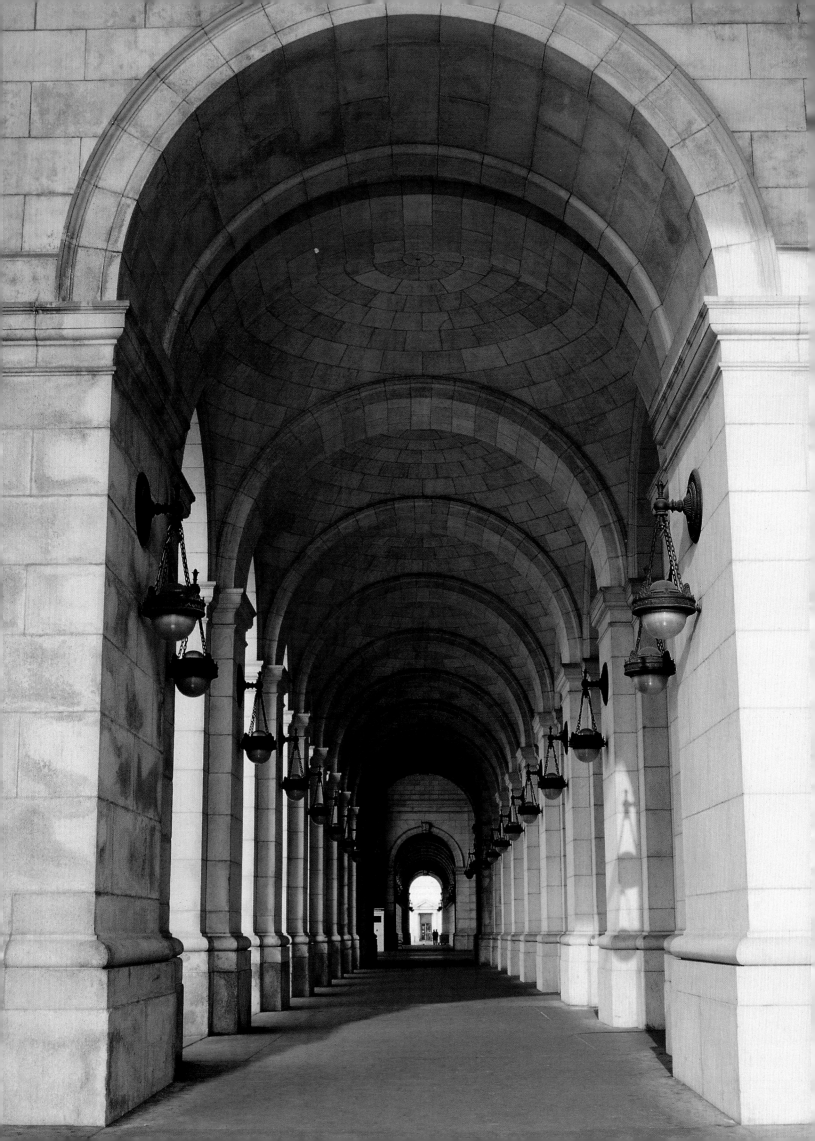

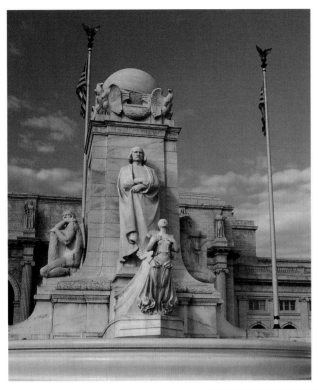

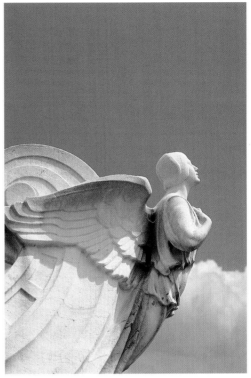

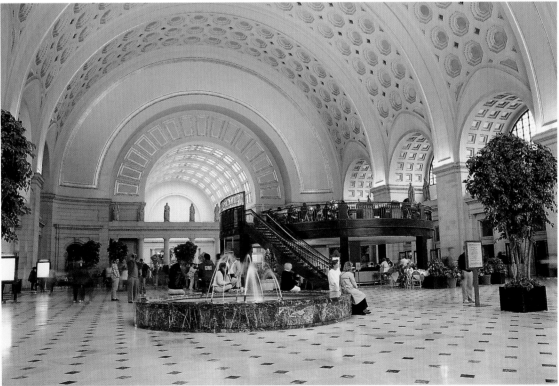

(previous overleaf) Lincoln Memorial.

(left, above, and overleaf) Union Station, interior and exterior; Columbus fountain and angel. Union Station is patterned after the ancient Roman Baths of Diocletian. It is also the site of inaugural balls and other special events.

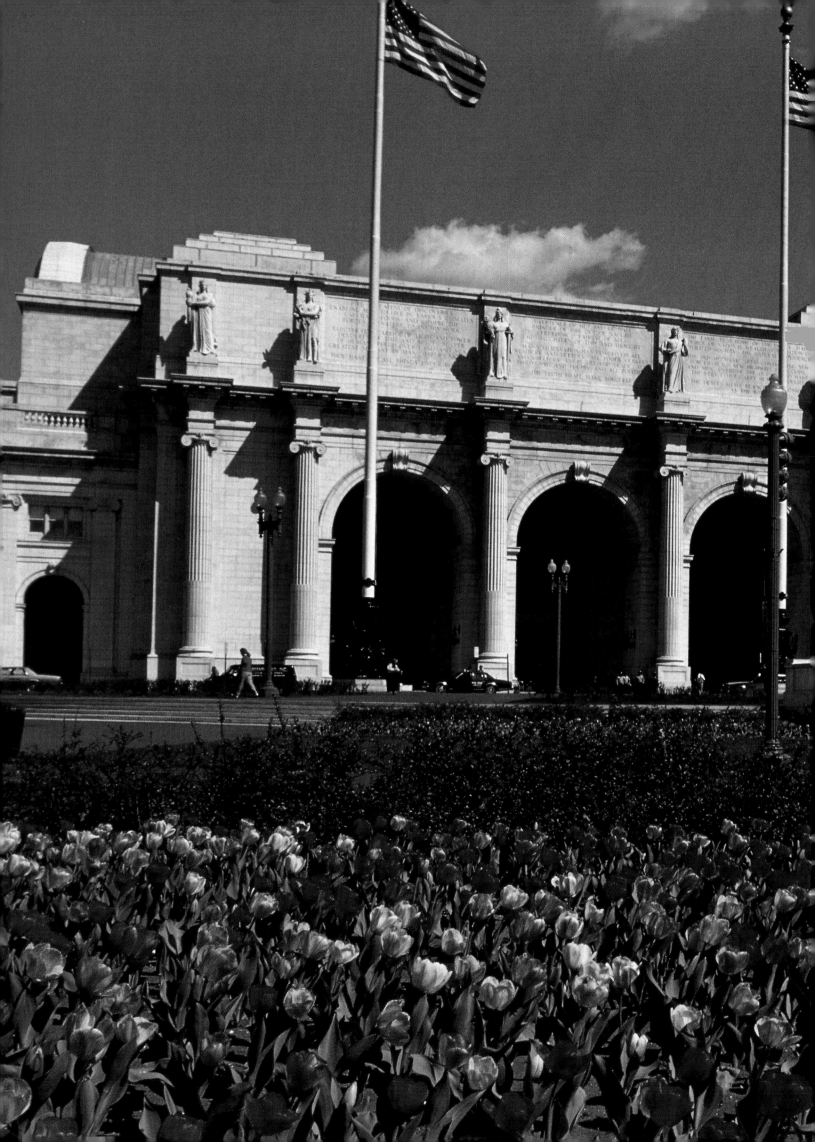

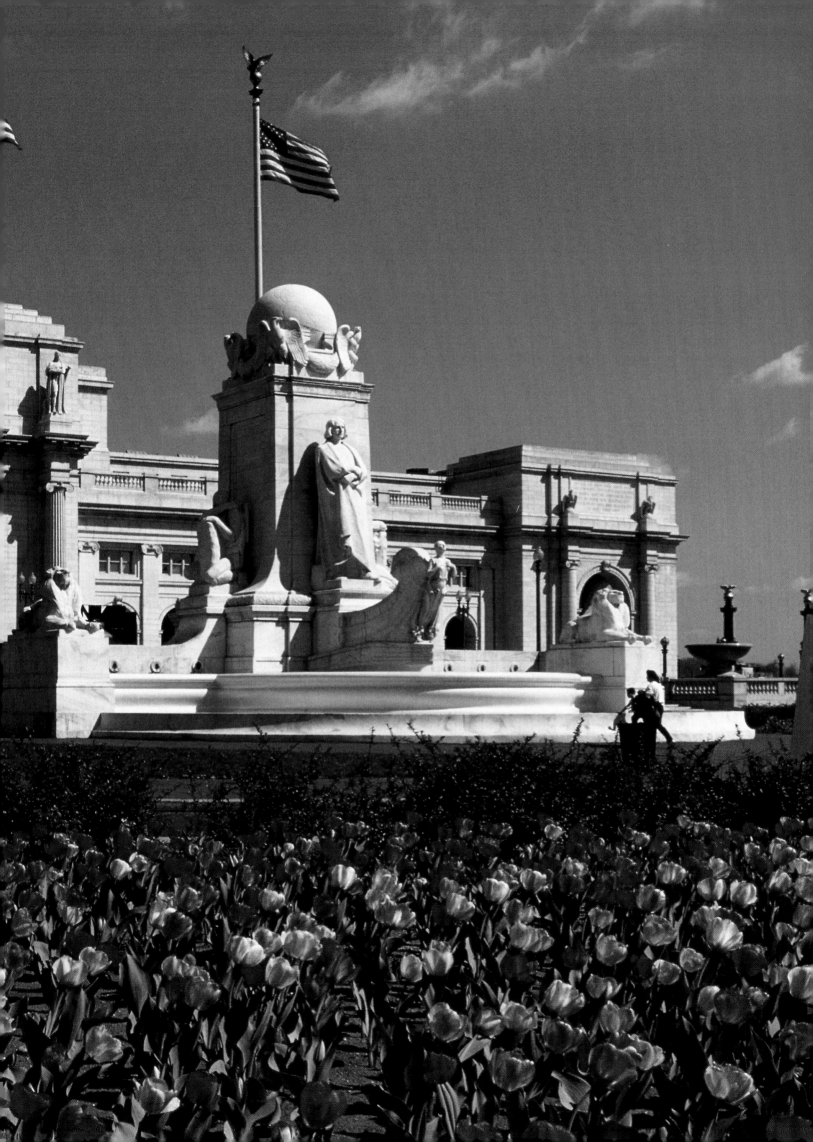

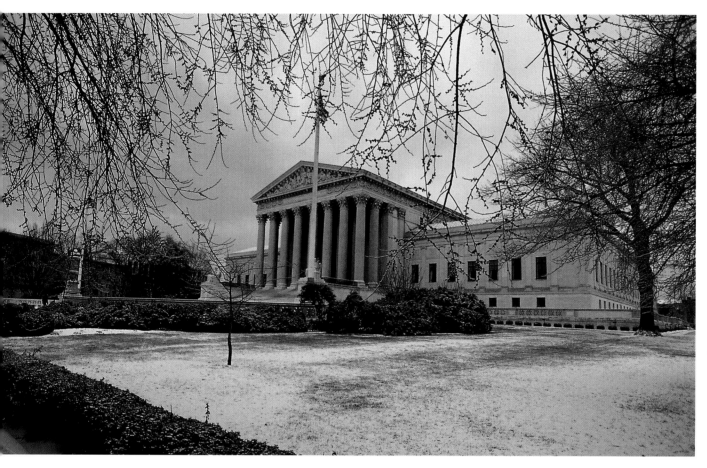

W ashington . . . is the symbol of America.
By its dignity and architectural,
we encourage that elevation of thought
and character which comes from
great architecture."

**Herbert Hoover (1874–1964)
American president**

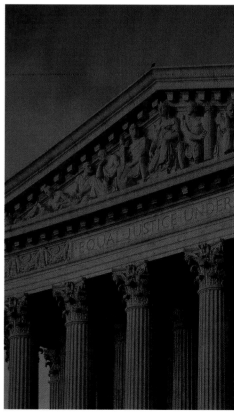

24 **(above, right, and opposite)** Supreme Court.

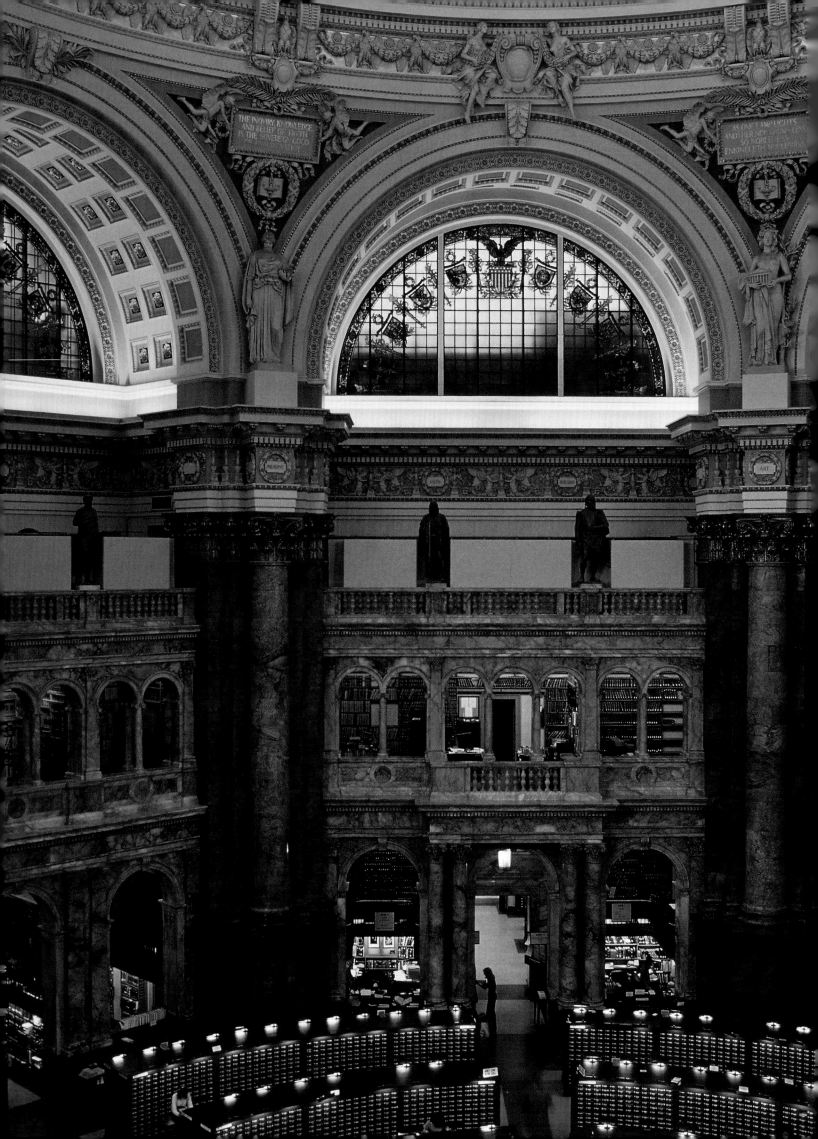

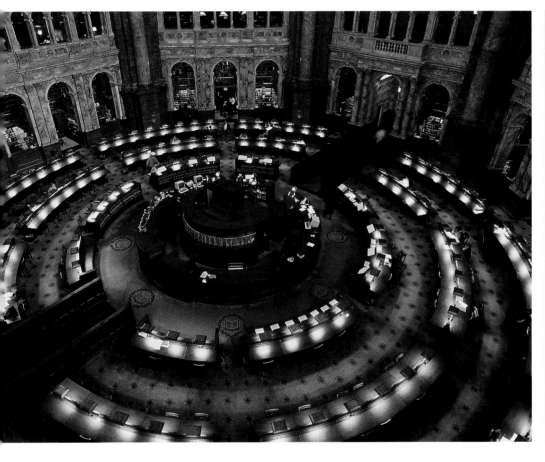

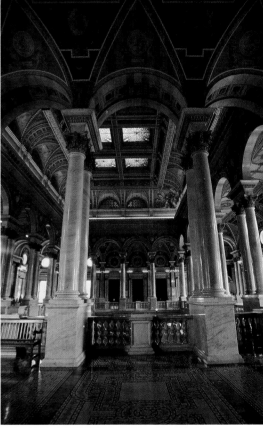

27 **(above and left)** The Library of Congress was created to provide reference books for the nation's senators and representatives. When the British burned Washington during the War of 1812, the books were destroyed. Former president Thomas Jefferson came to the library's rescue by offering his collection of more than 6,000 books.

(overleaf) The Smithsonian.

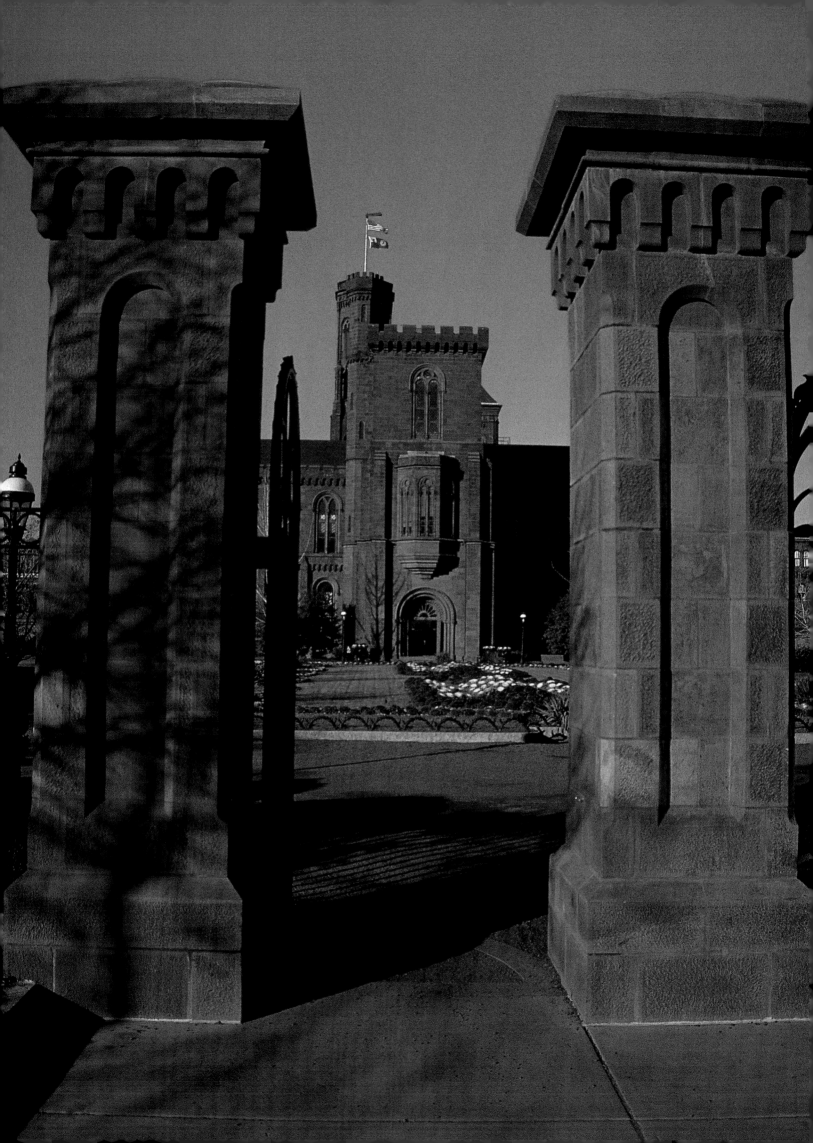

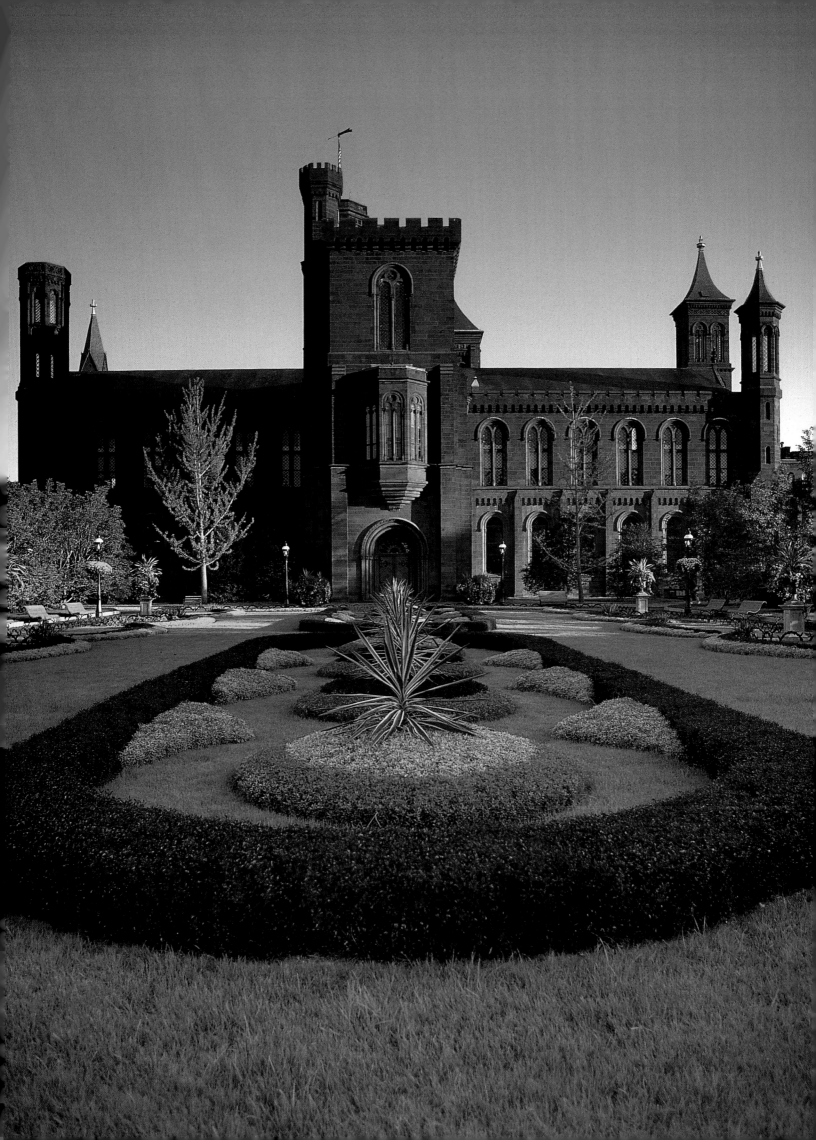

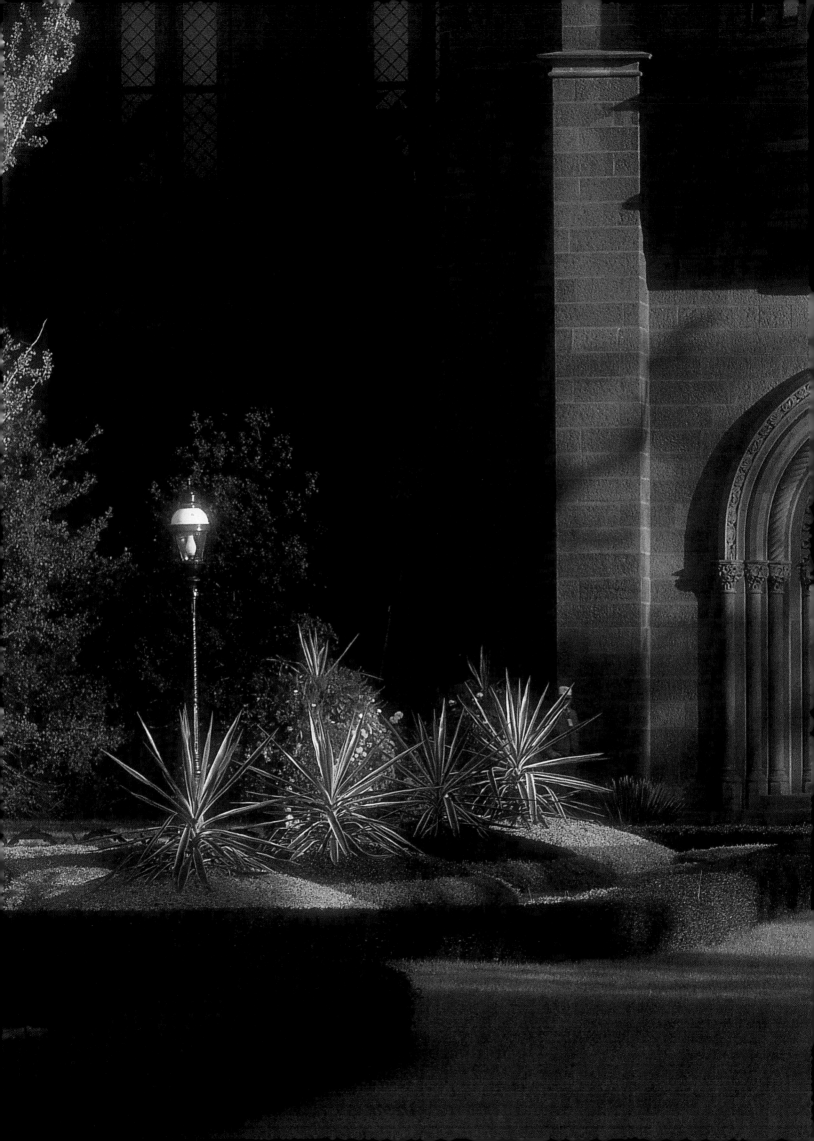

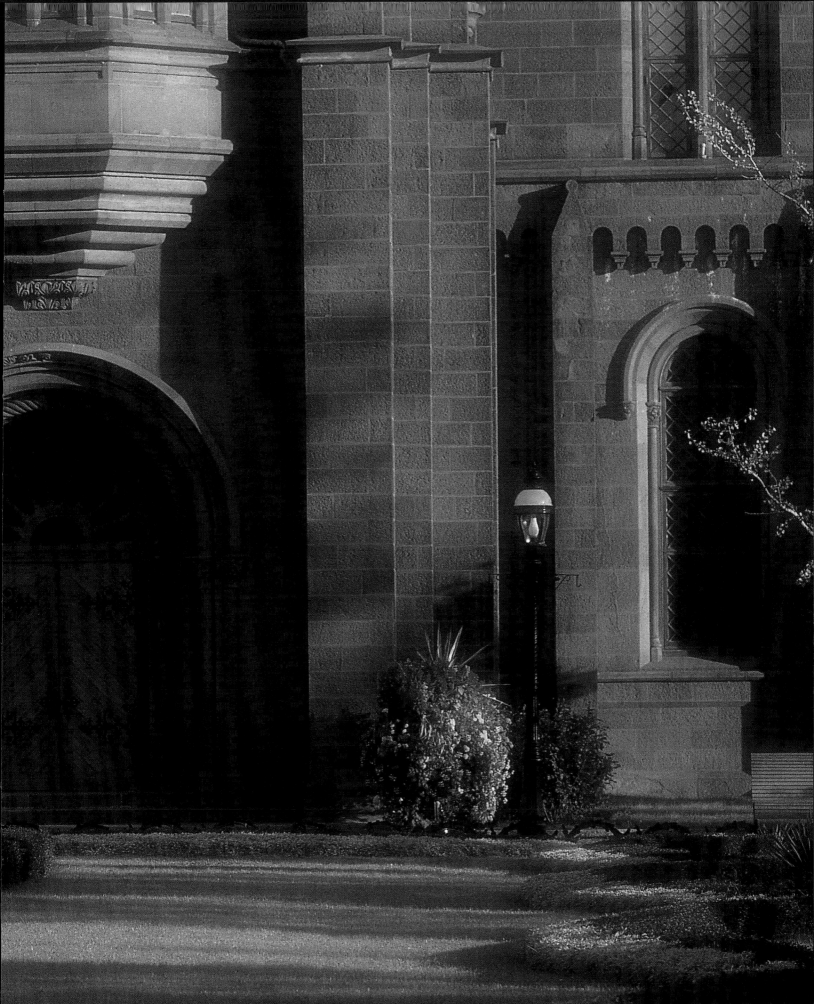

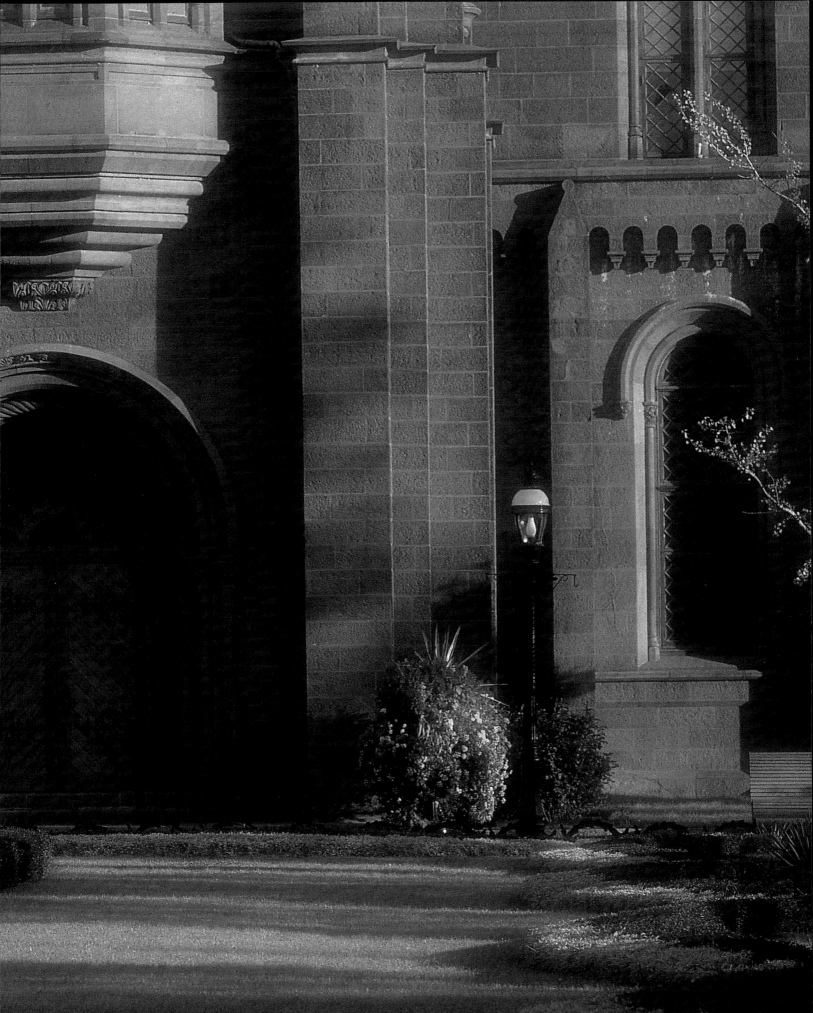

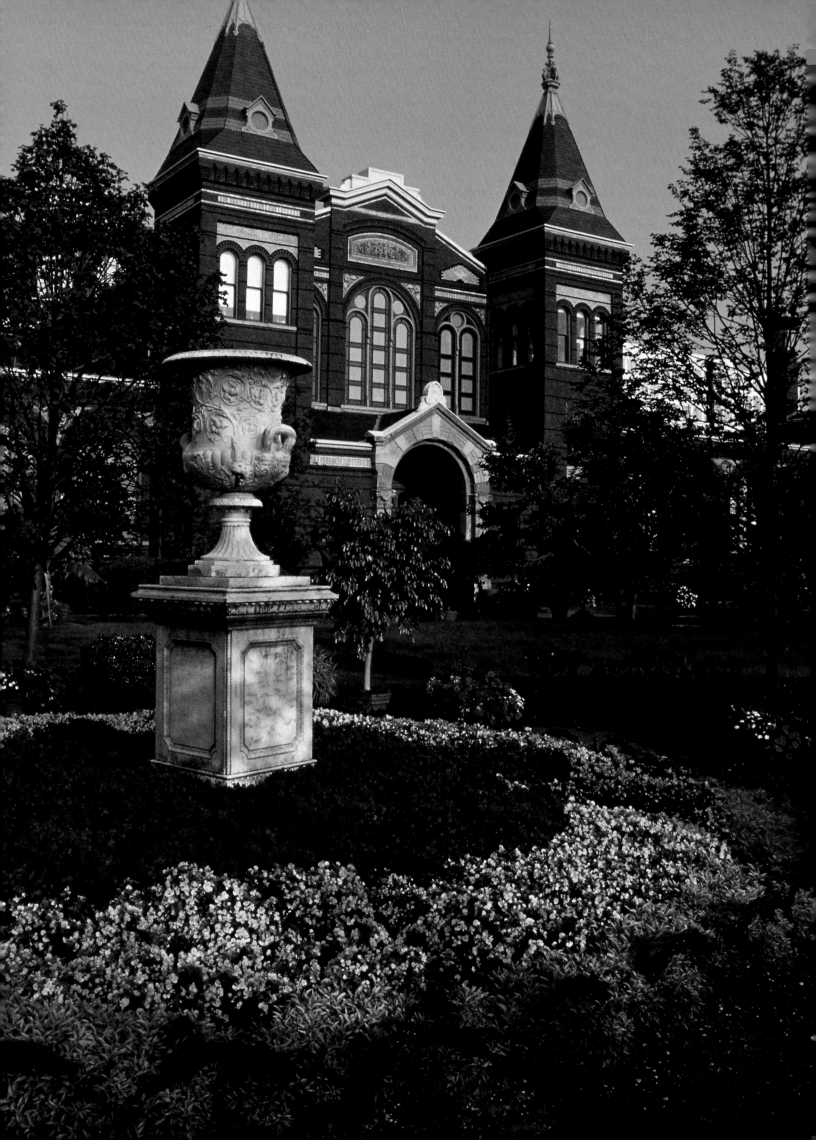

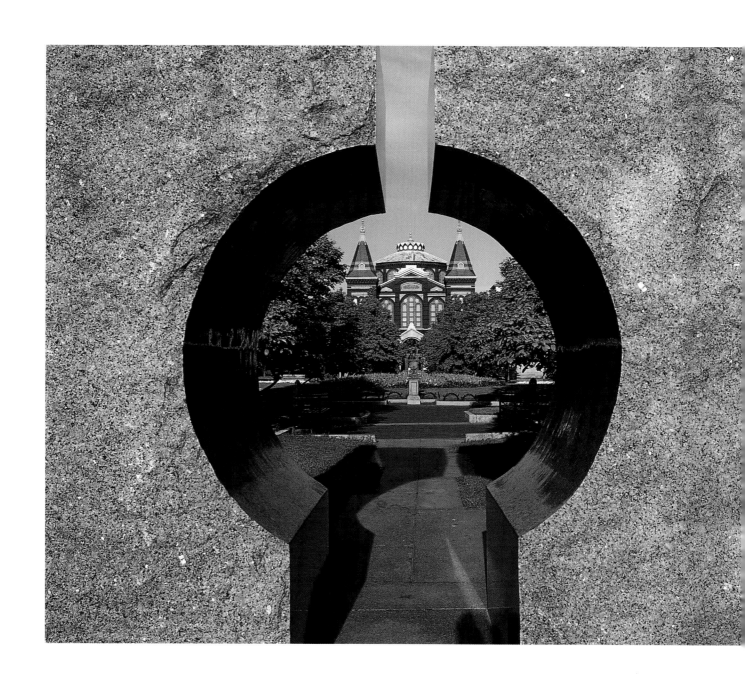

33 **(previous overleaf, left and above)** The Smithsonian Institution and the Enid Haupt Gardens. The Smithsonian Institution was founded by Congress at the bequest of James Smithson, an English scientist who left his entire fortune to a country he had never seen ". . . to found at Washington, under the name of the Smithsonian Institution an Establishment for the increase and diffusion of knowledge. . . ."

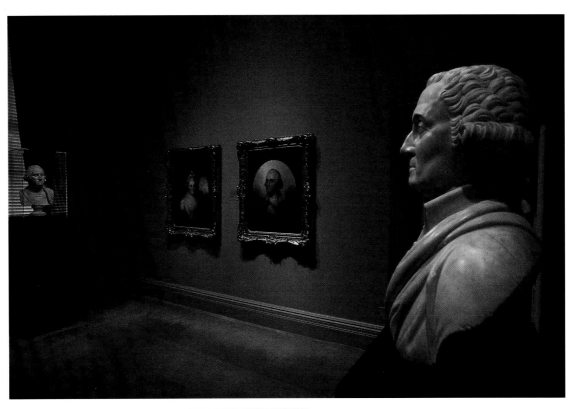

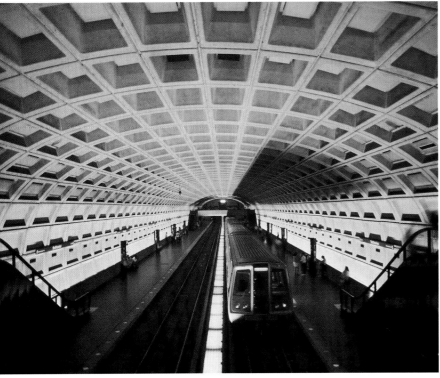

34 **(top)** Smithsonian Portrait Gallery. **(bottom)** Smithsonian Metro stop. **(right)** Jefferson Monument.

(overleaf) Jefferson Monument at night.

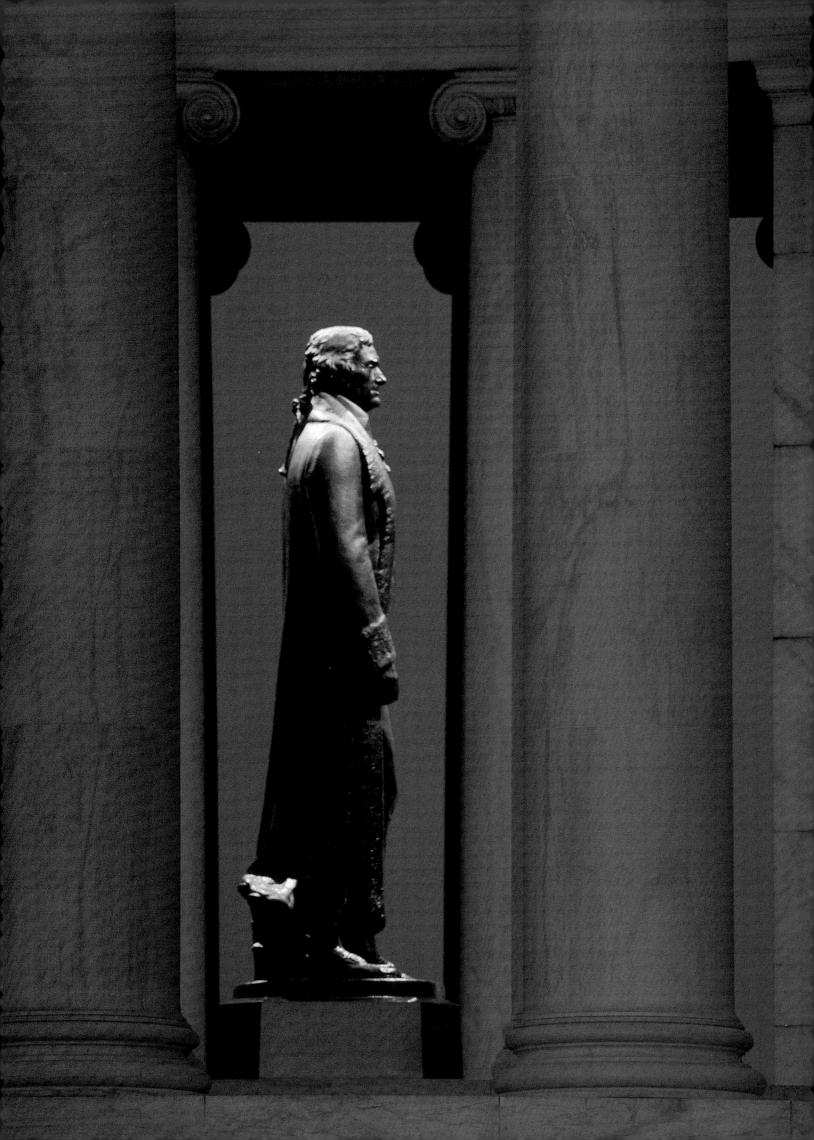

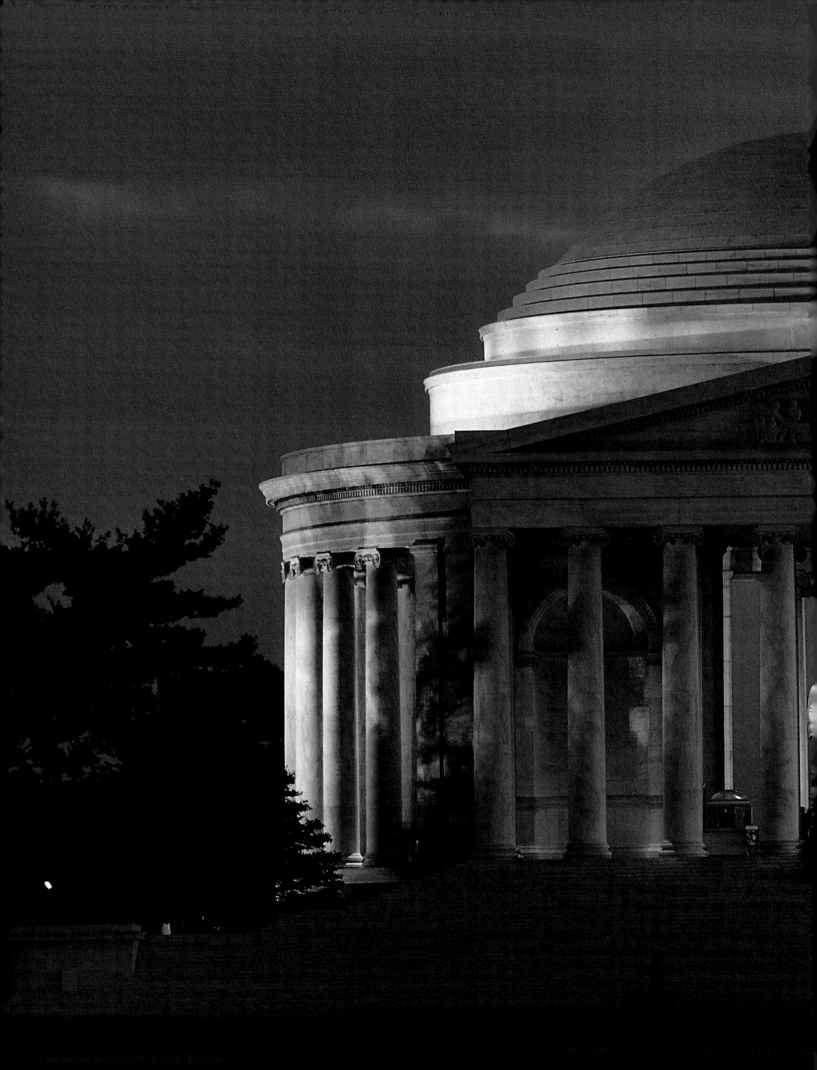

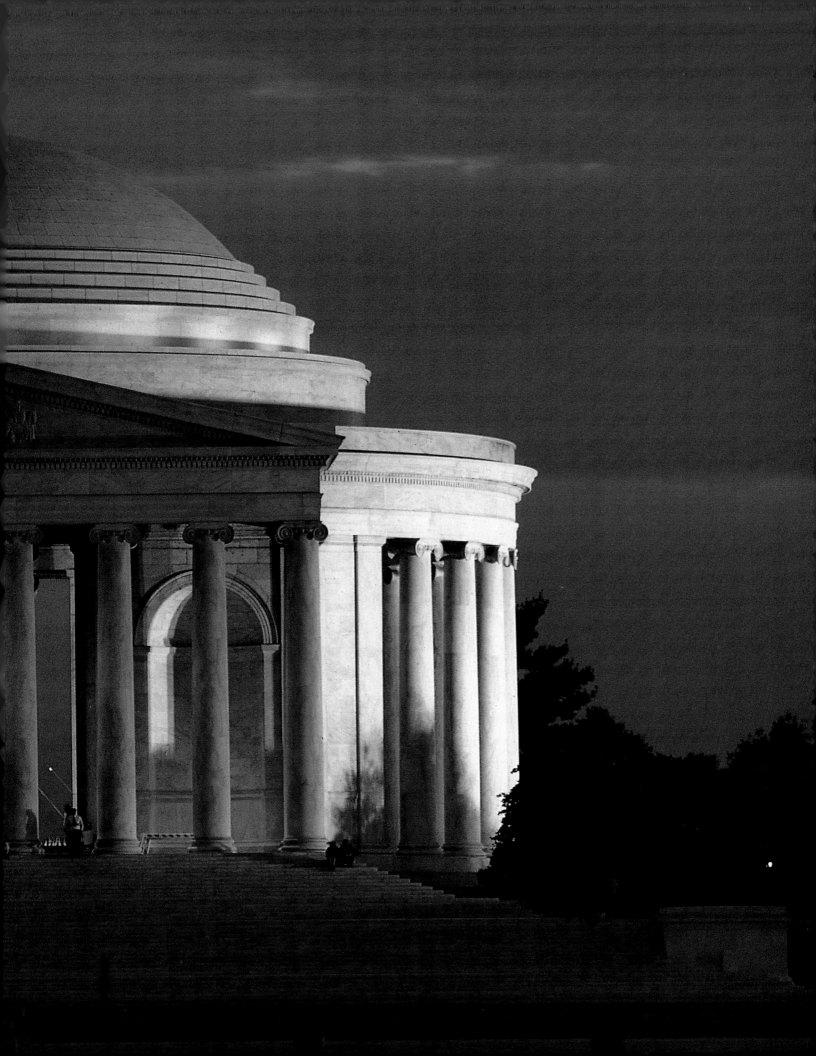

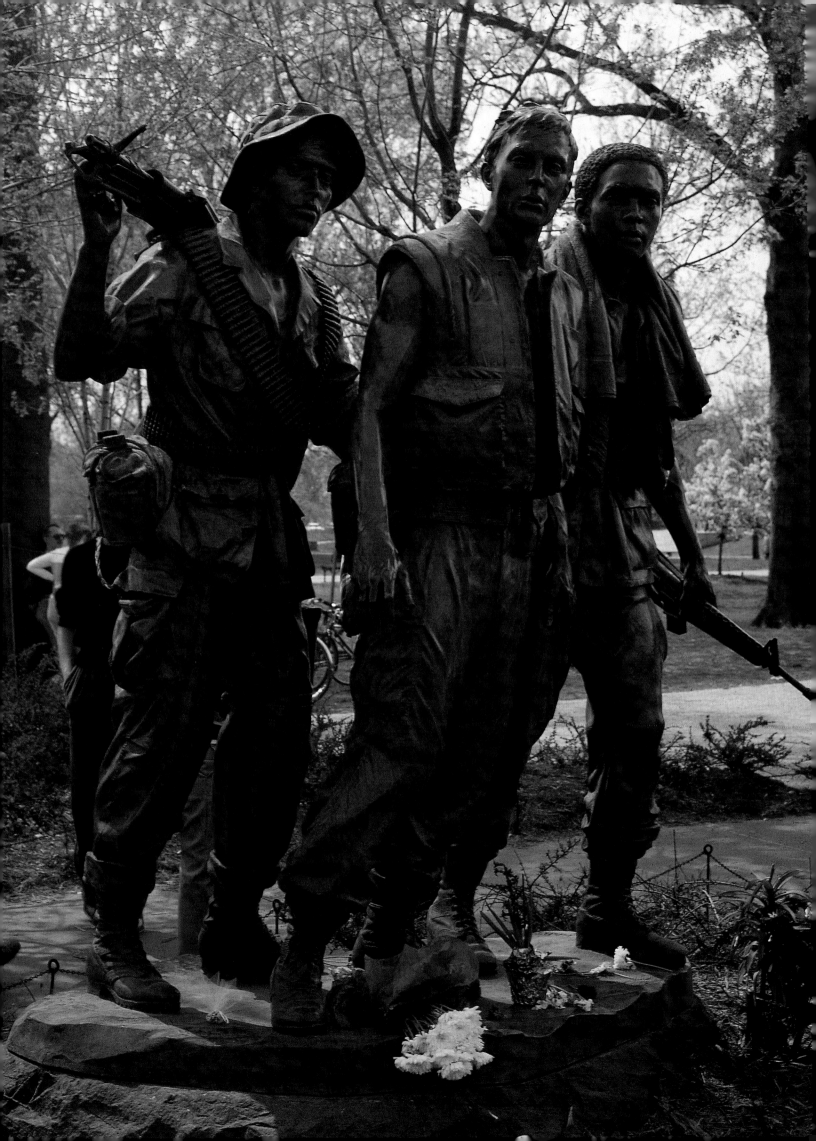

W

hatever we are looking for, we come to Washington in millions to stand in silence and try to find it."

Bruce Catton (1899–1978)
American historian

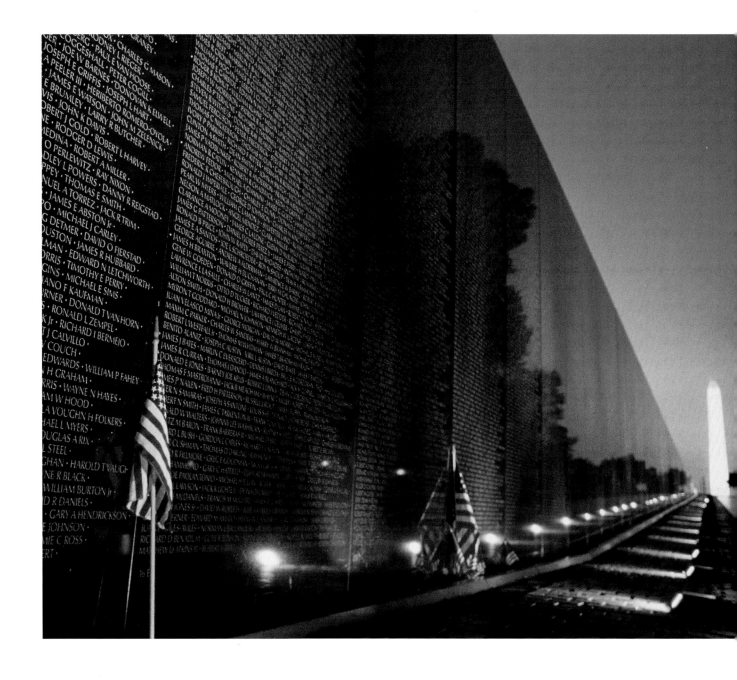

(left) Vietnam Veterans Scupture. **(above)** Vietnam Veterans Memorial. Three soldiers look toward the wall bearing the names of their fallen comrades in sculptor Frederick Hart's tribute to the men who fought in Vietnam.

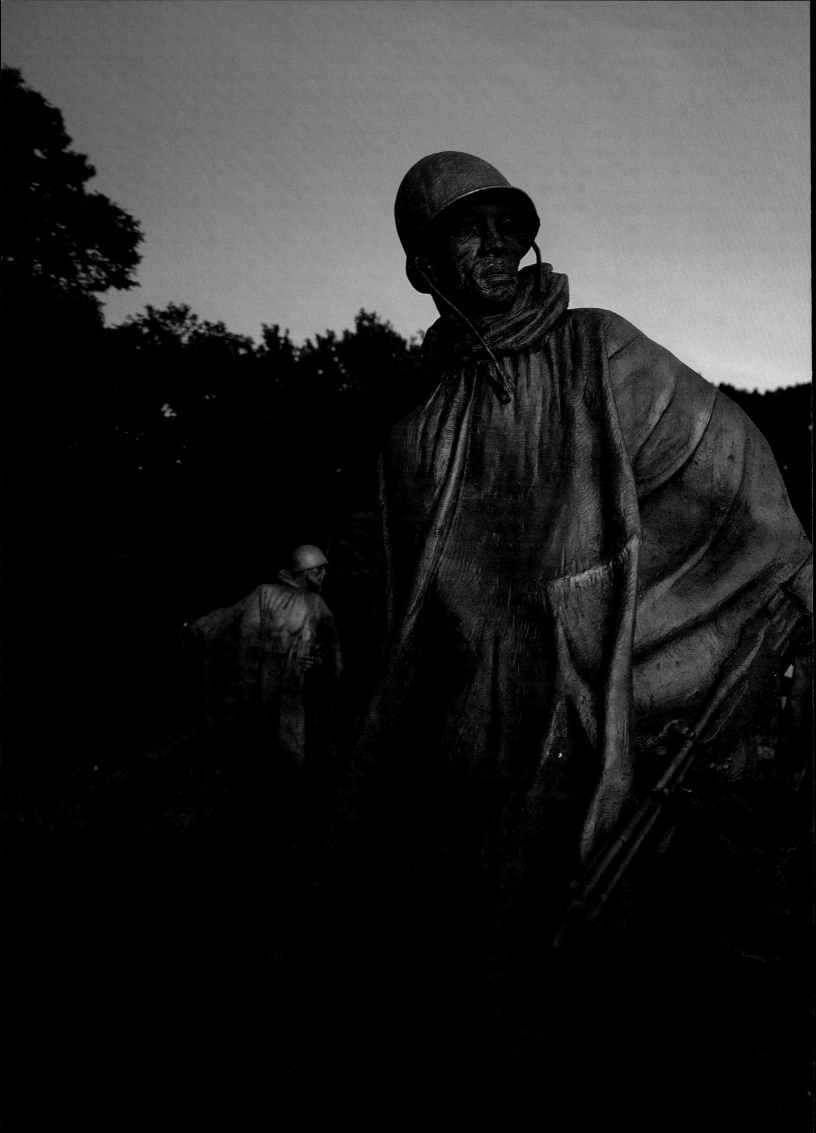

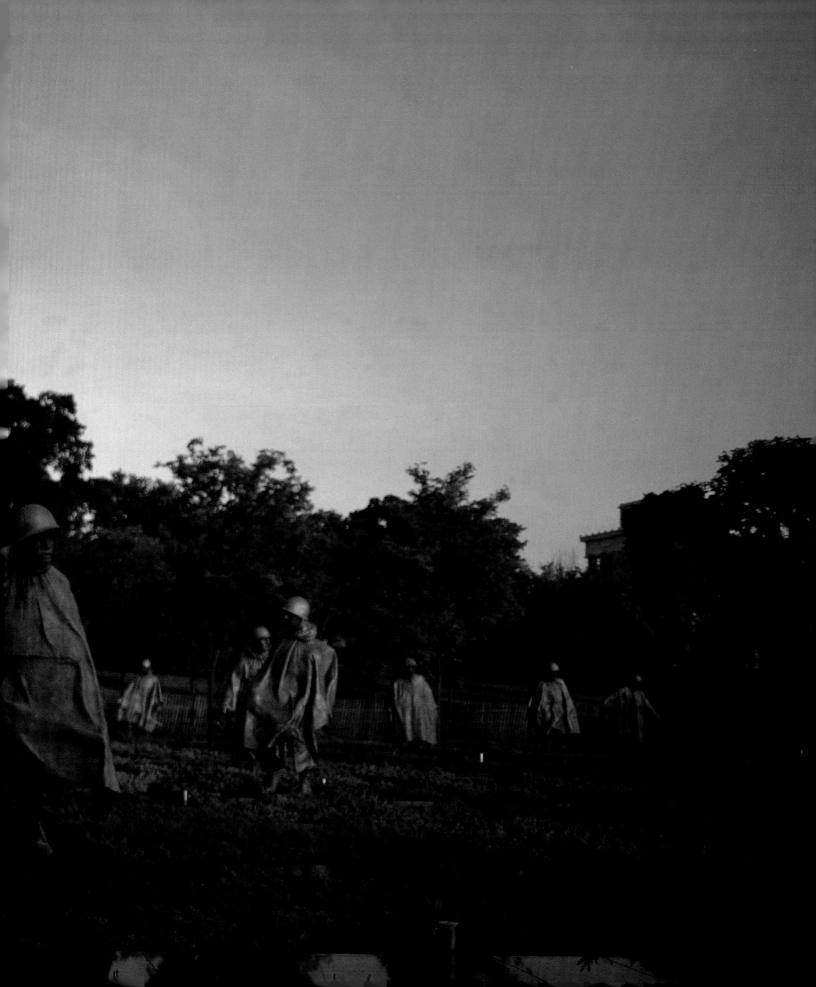

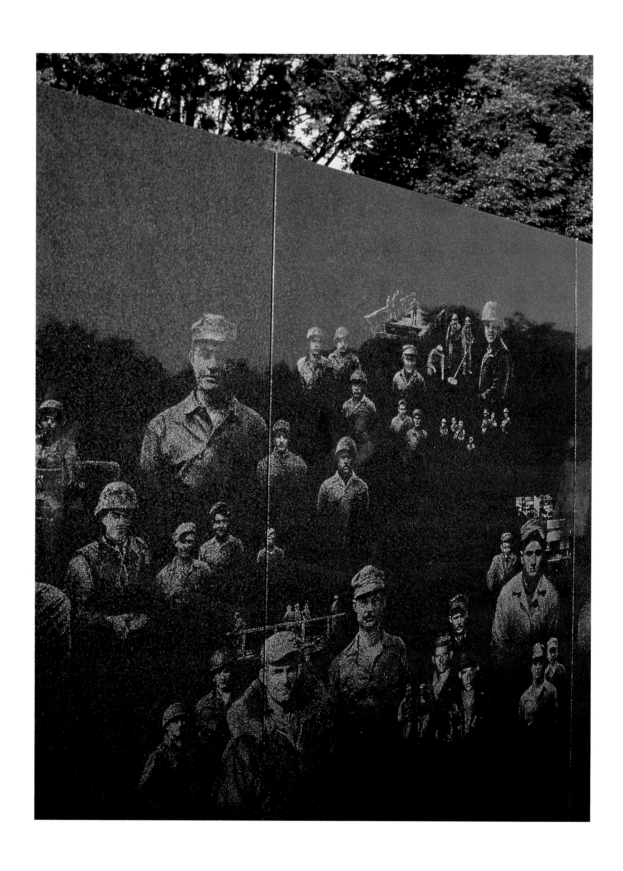

42 **(previous overleaf and above)** Korean War Memorial. The Korean War Veterans Memorial honors the 1.5 million Americans who served in Korea from 1950 to 1953. The larger-than-life statues of soldiers on patrol serve as eerie reminders of the dangers faced by our military men and women. **(right)** Holocaust Memorial Museum.

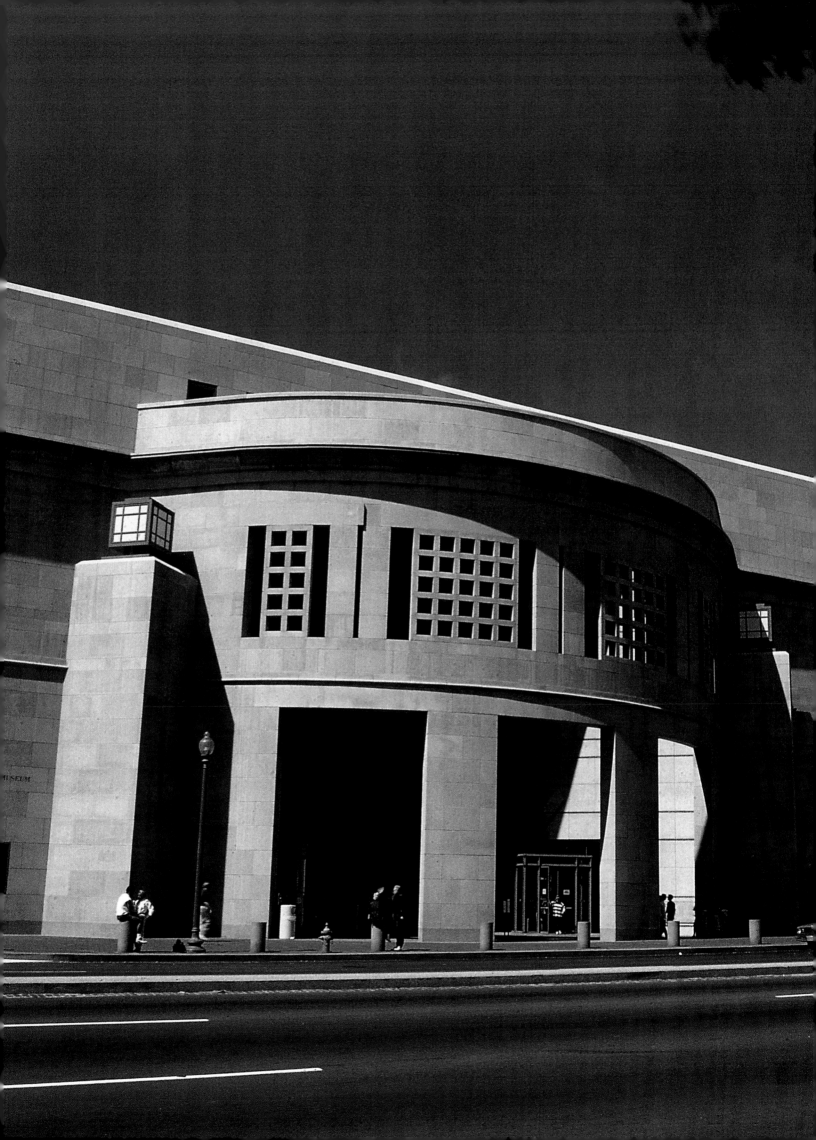

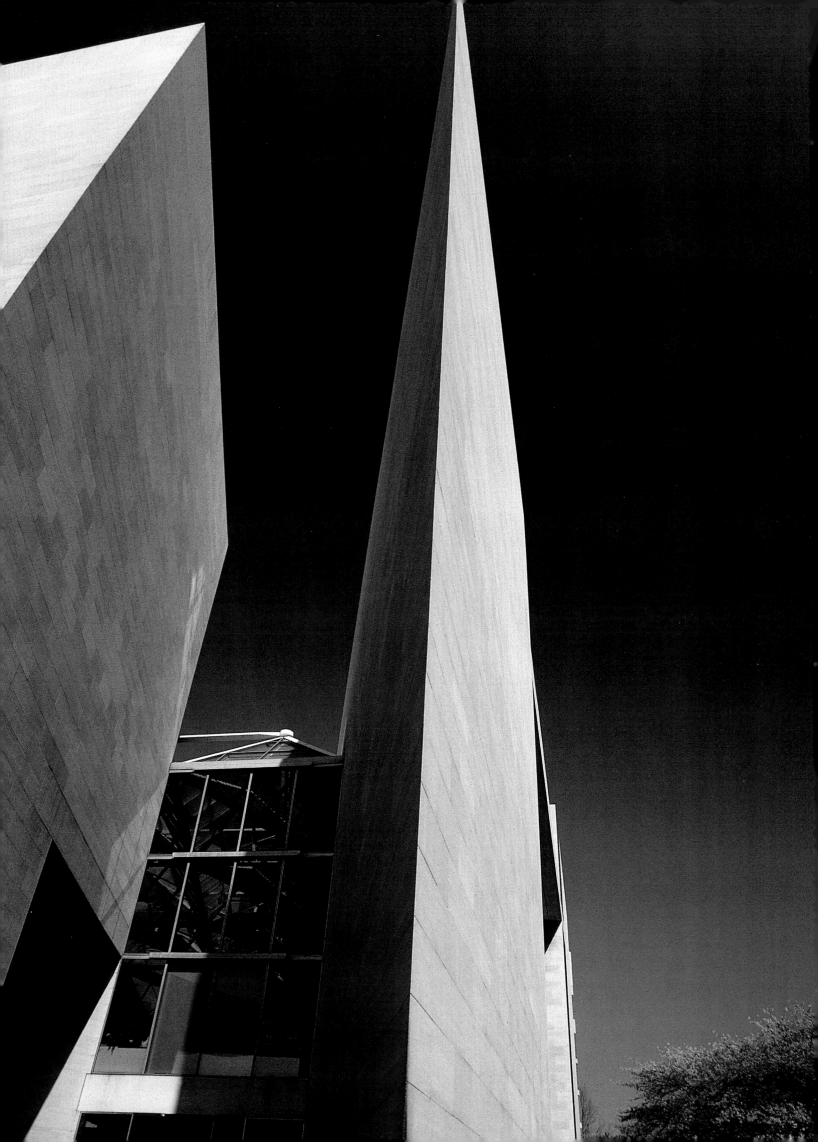

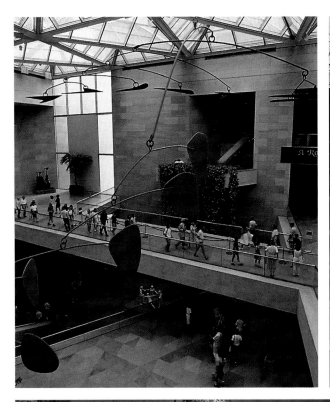

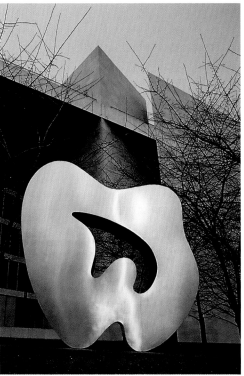

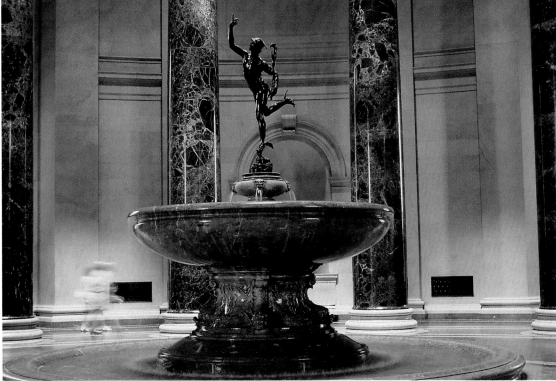

45 **(left and above)** National Gallery of Art.

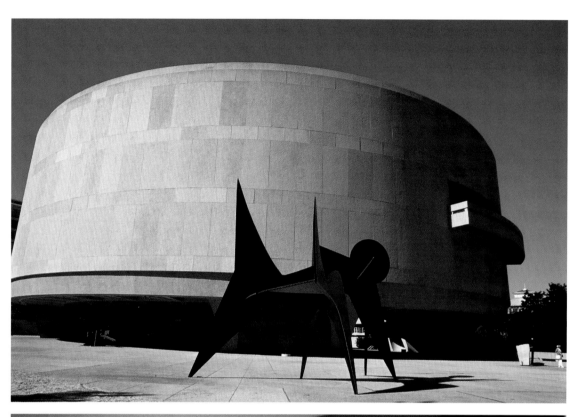

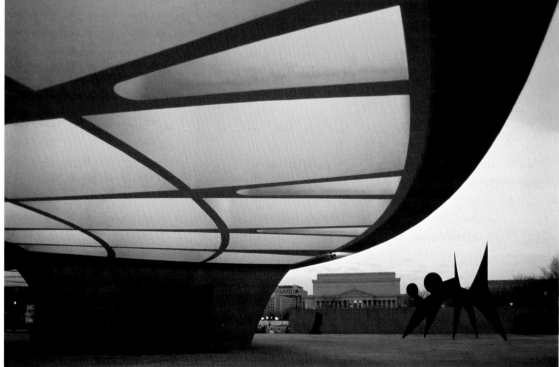

46 (**above**) Hirschorn Museum. (**right**) The Civil War Monument.

(**overleaf**) The National Air and Space Museum.

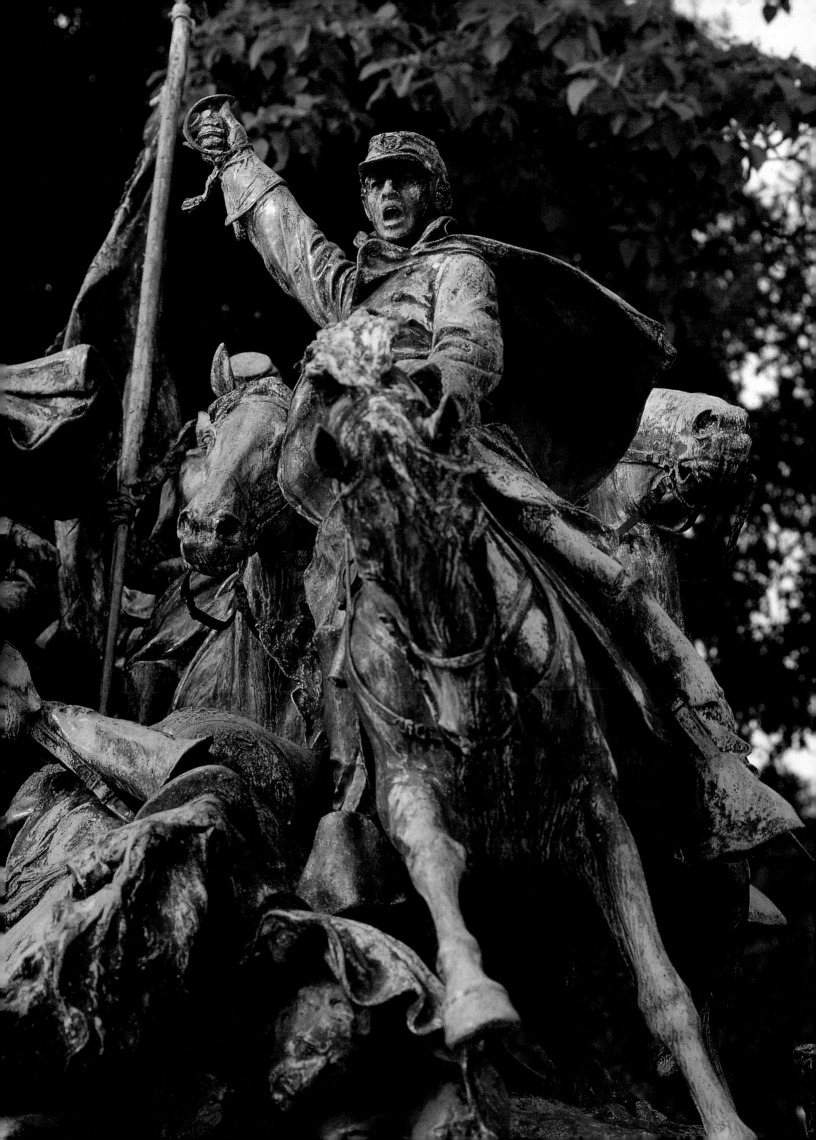

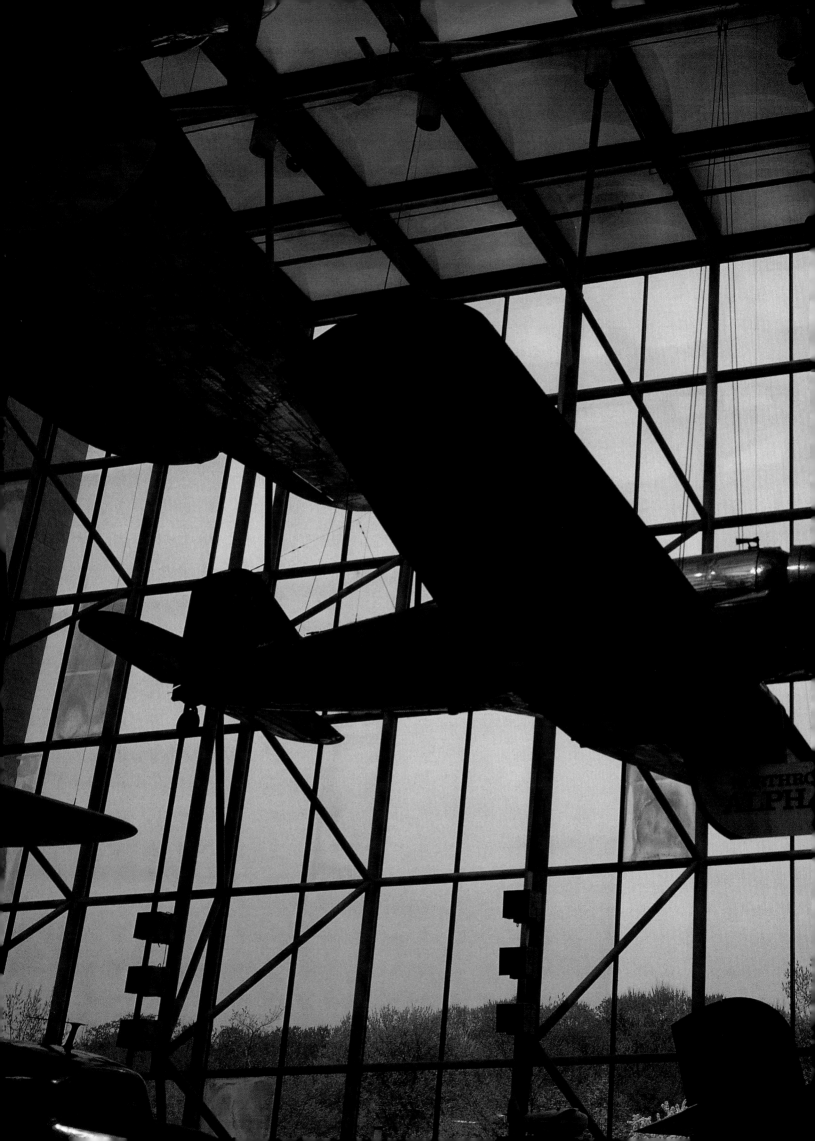

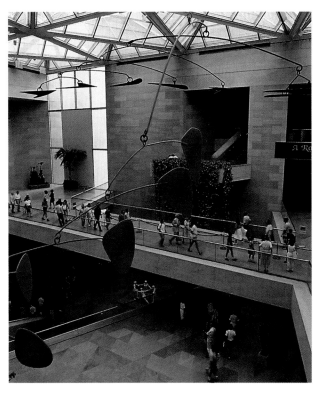
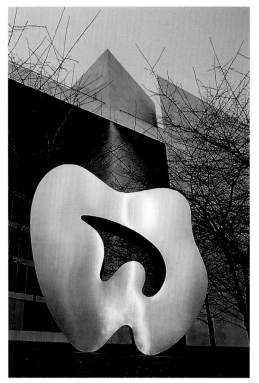

45 **(left and above)** National Gallery of Art.

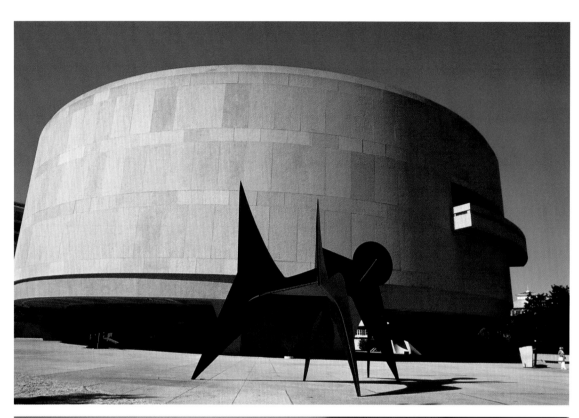

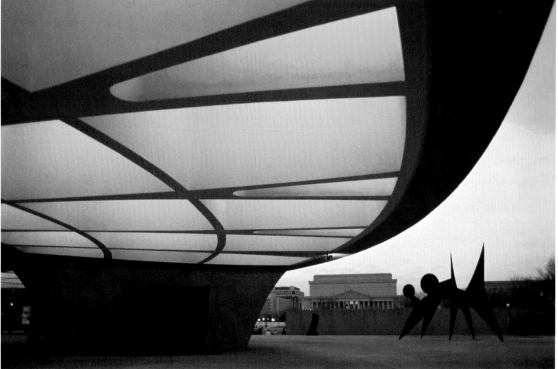

46 **(above)** Hirschorn Museum. **(right)** The Civil War Monument.

(overleaf) The National Air and Space Museum.

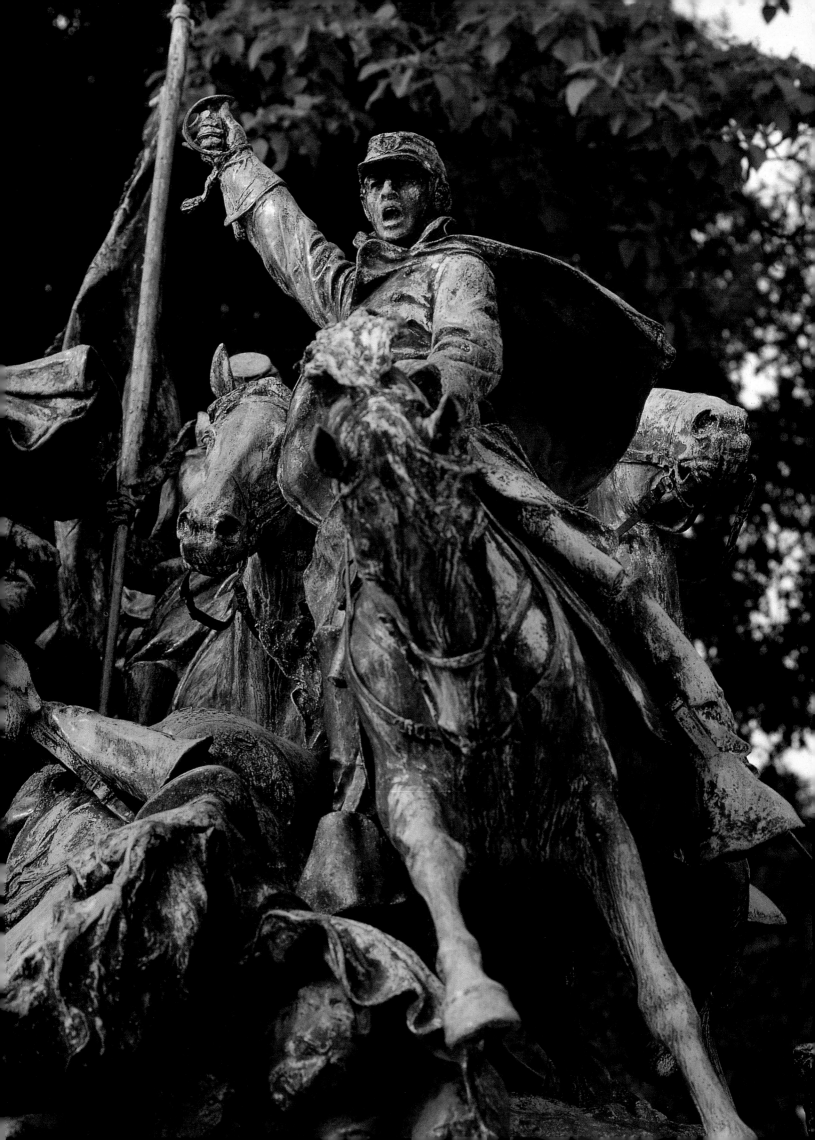

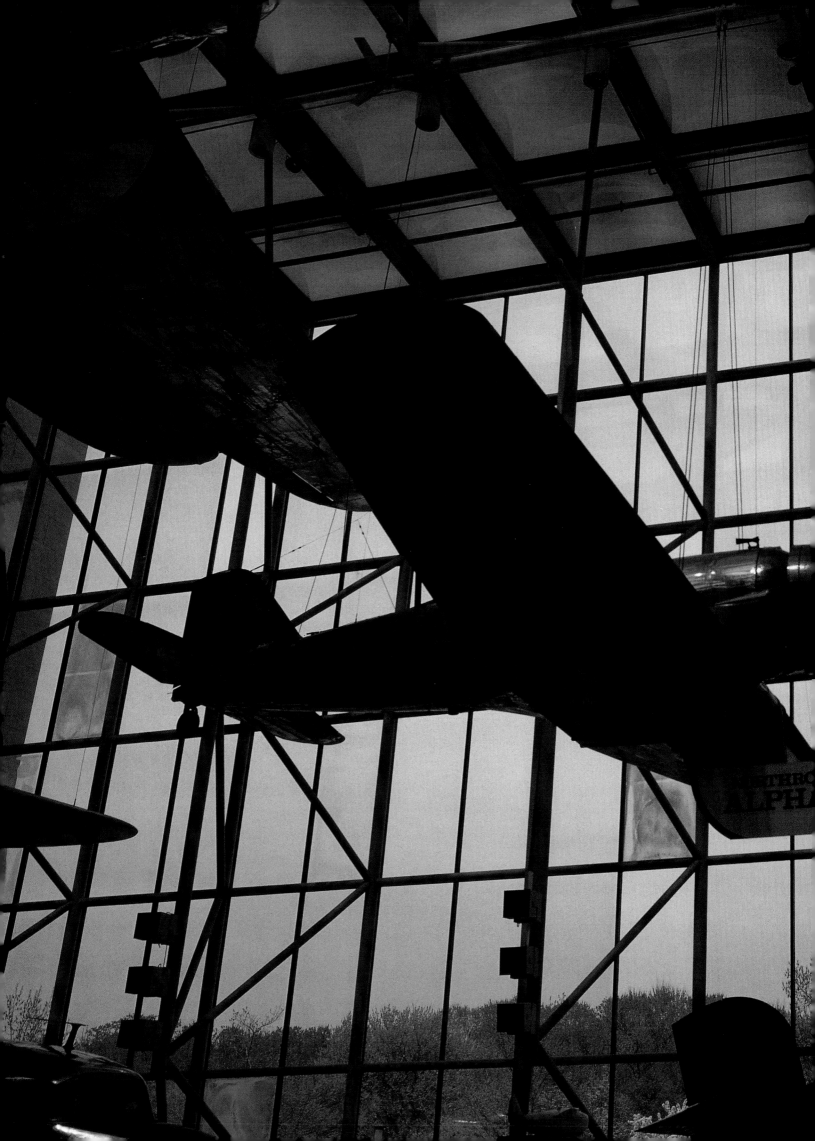

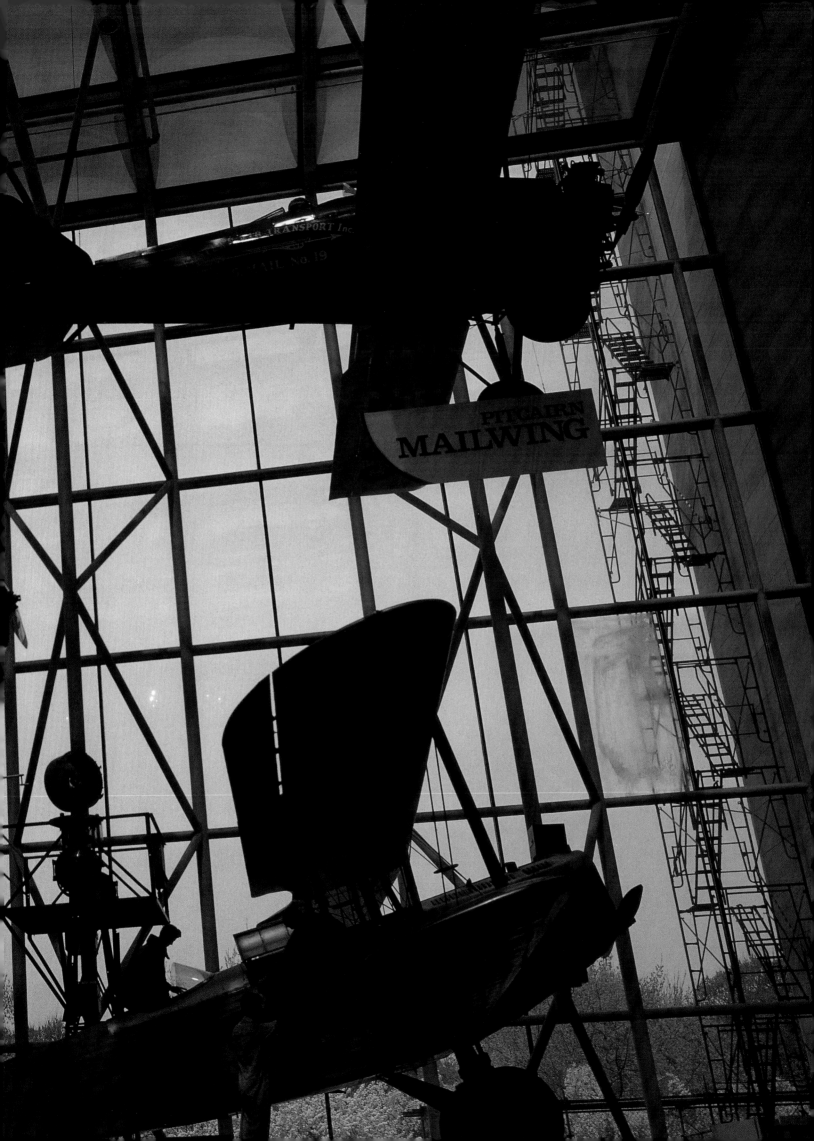

PITCAIRN
MAILWING

AIR MAIL No. 19

TRANSPORT Inc.

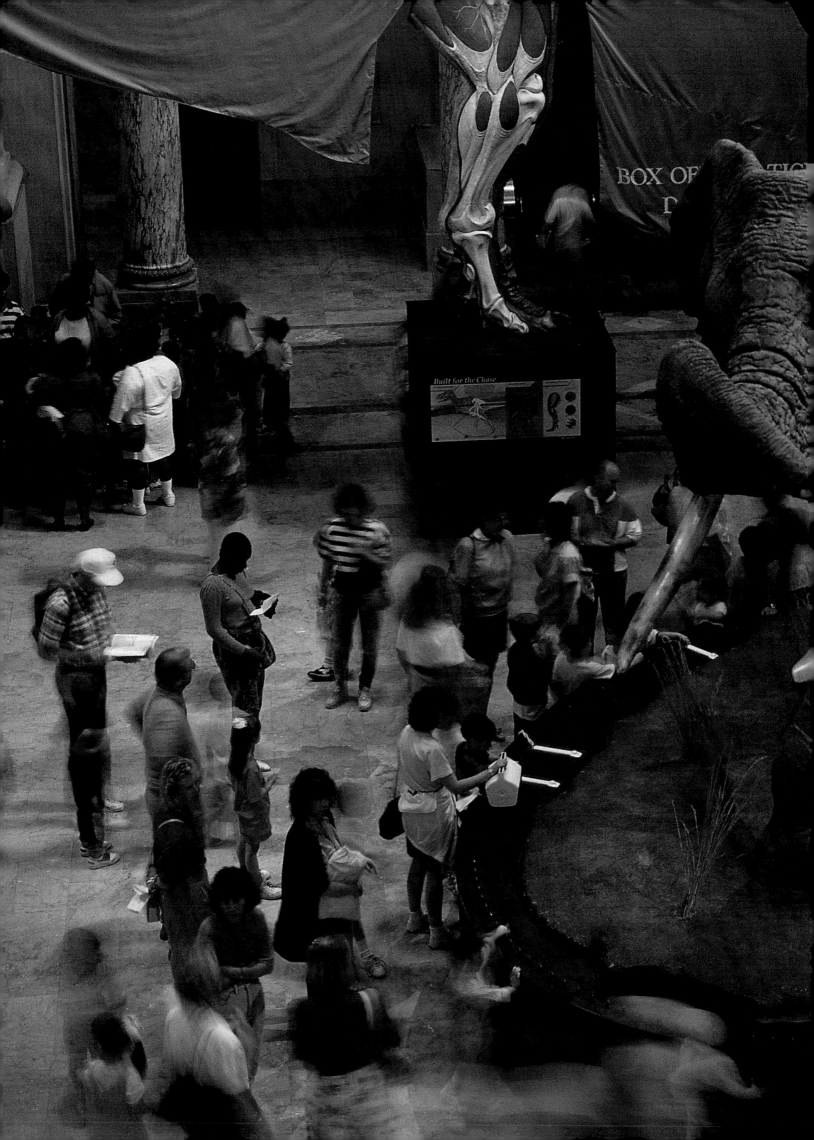

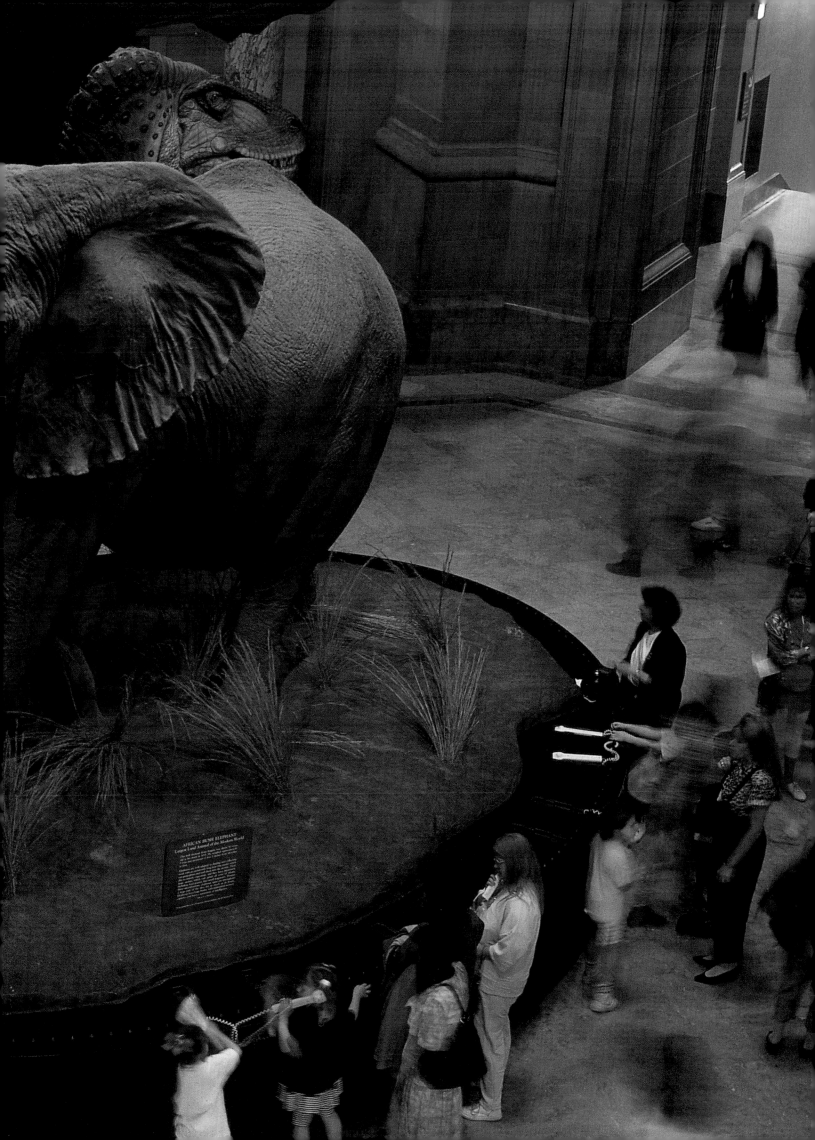

AFRICAN BUSH ELEPHANT
Largest Land Animal of the Modern World

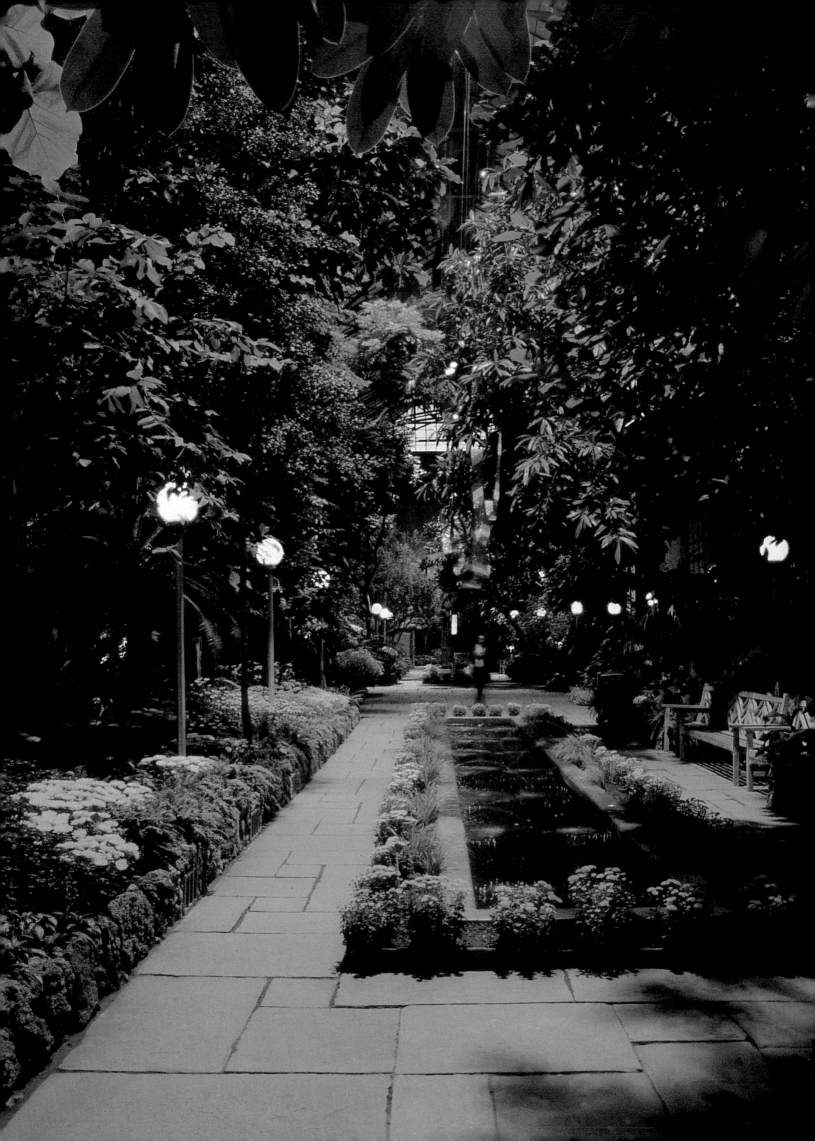

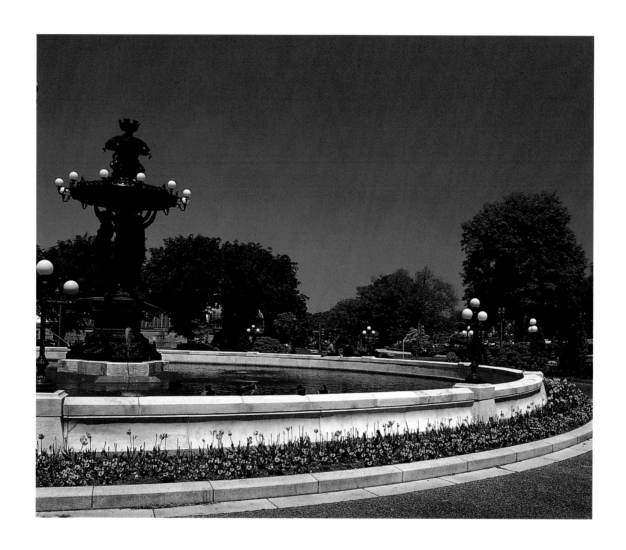

Were it not for the parks and monuments and great federal buildings that break up the monotony, downtown Washington would be a visual and architectural disaster."

Jonathan Yardley
20th-century American journalist

(**previous overleaf**) National Museum of Natural History.

(**left**) U.S. Botanical Gardens. (**above**) Bartoldi Park and Fountain.

(**overleaf**) National Archives Building and the WWI Memorial. The National Archives store the government's documents, including the Declaration of Independence, the Constitution, and the Bill of Rights.

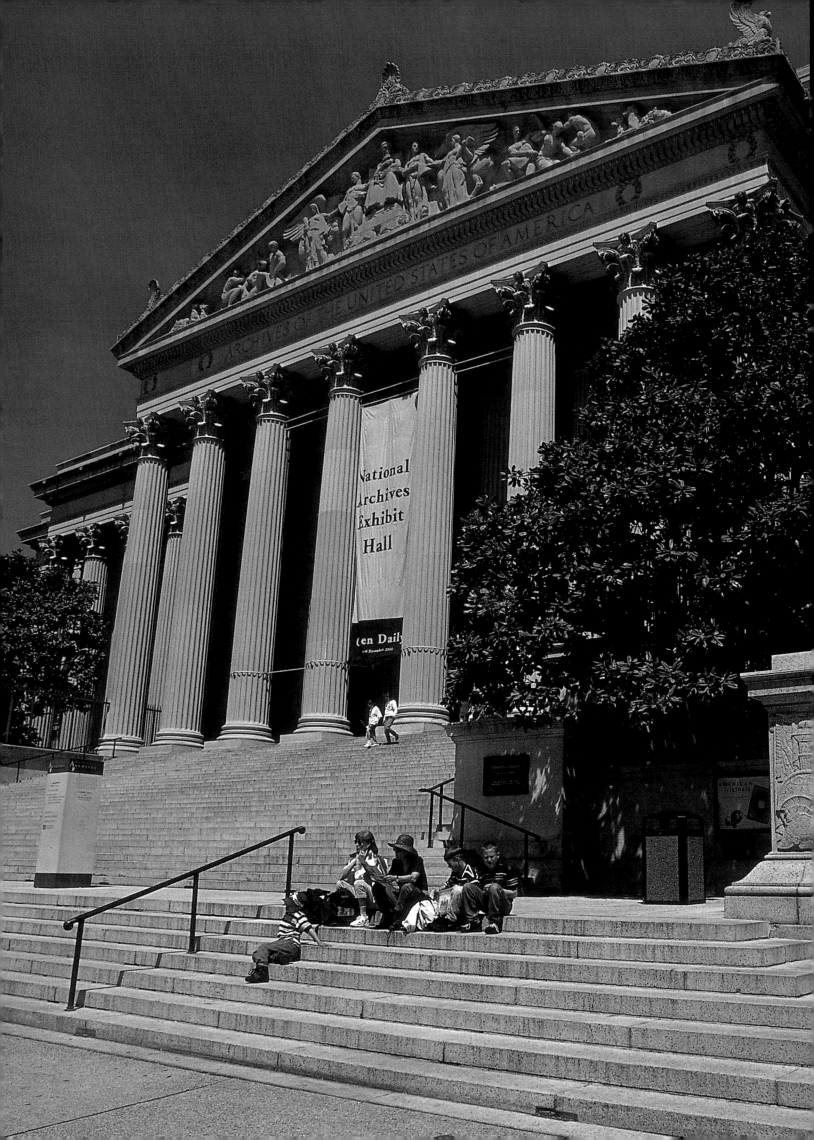

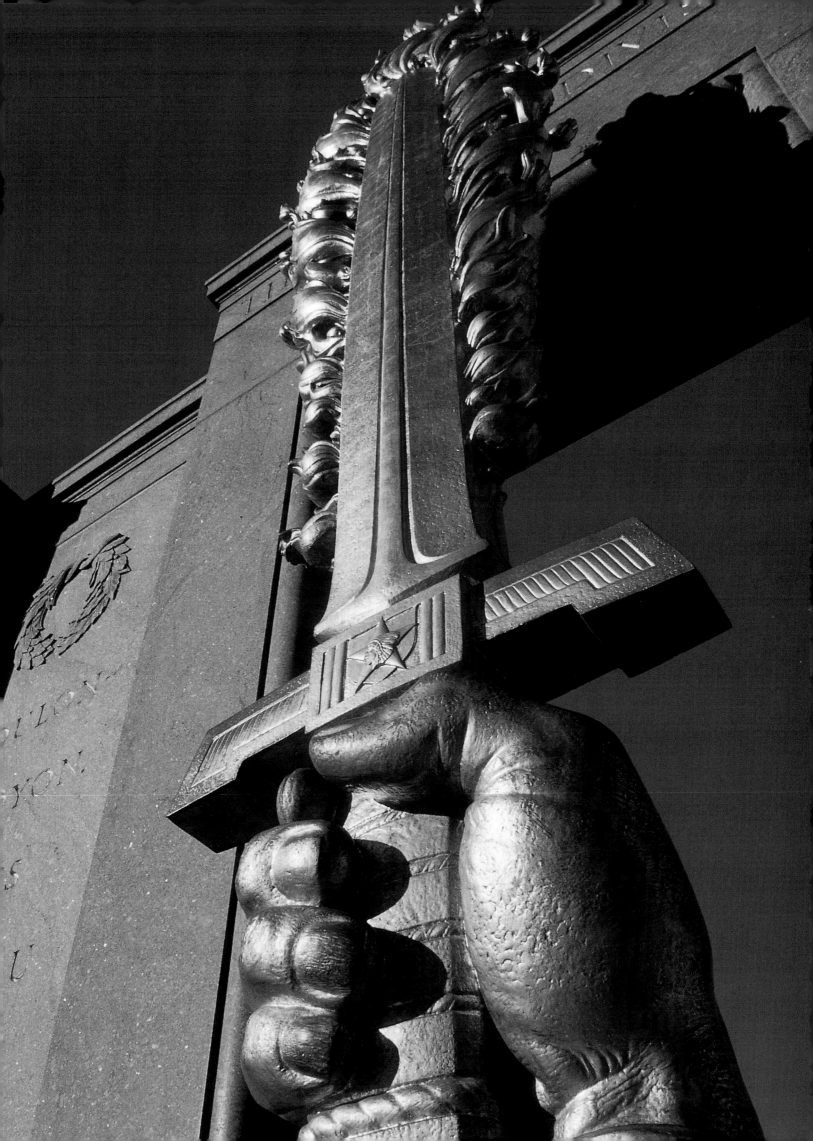

I pray heaven to bestow the best of blessings on this house, and on all that shall hereafter inhabit it. May none but honest and wise men ever rule under this roof."

John Adams (1735–1826)
First American president to live in the White House

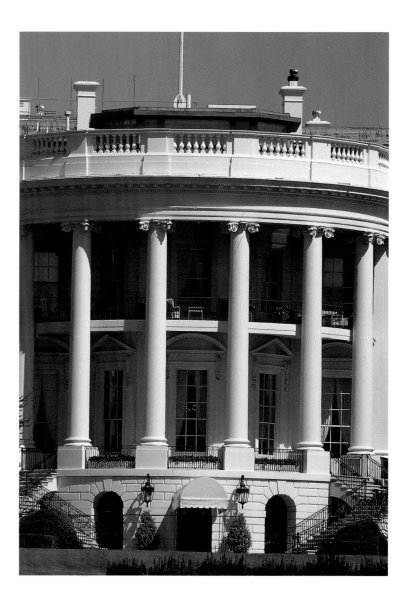

(above and right) The White House, interior and exterior.

(overleaf) The White House in winter.

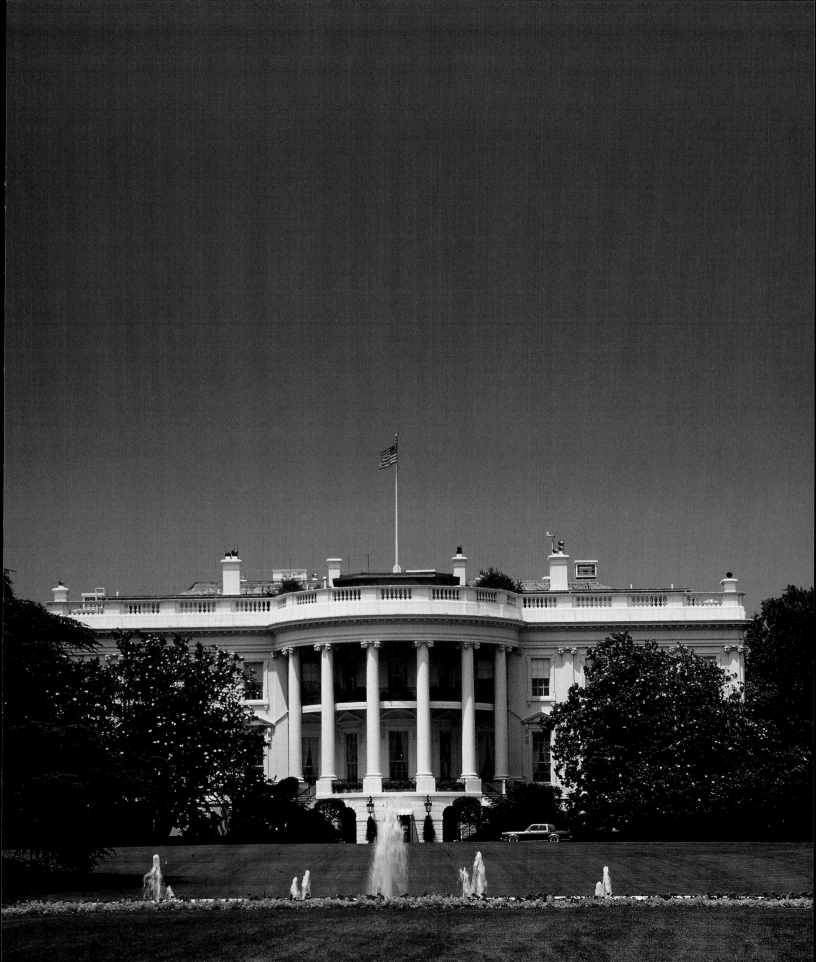

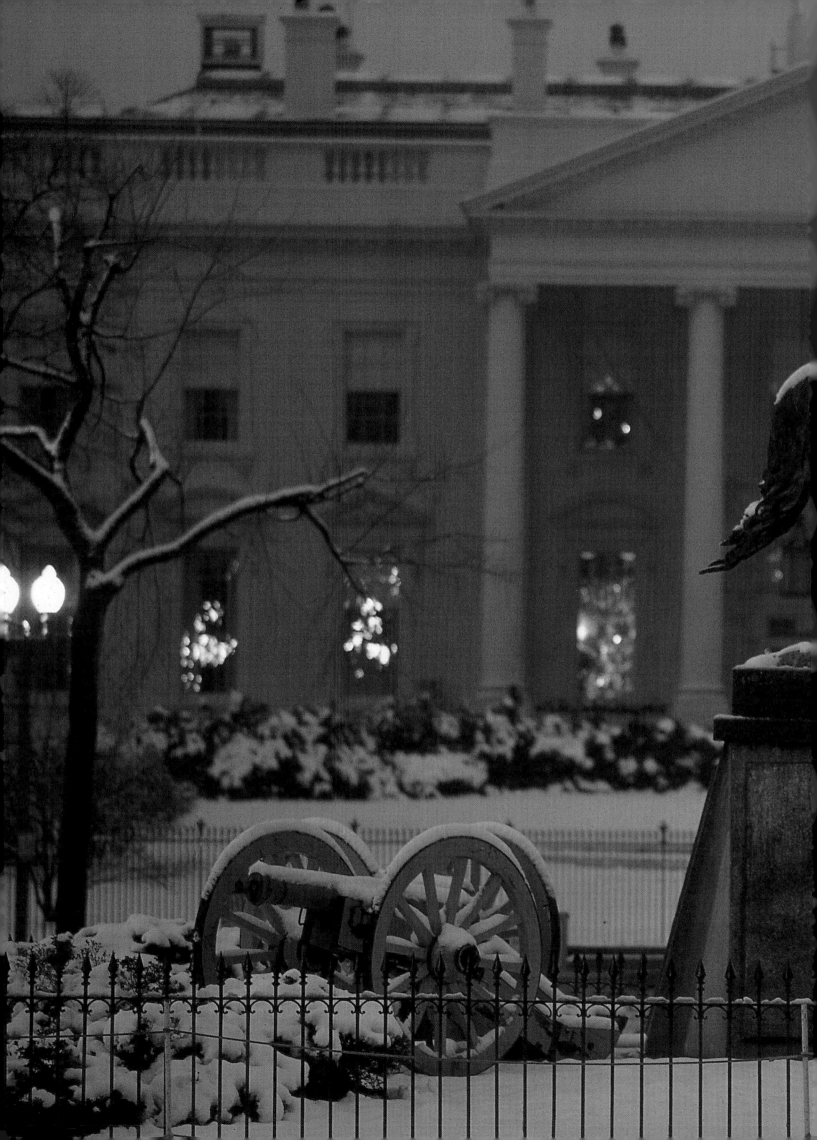

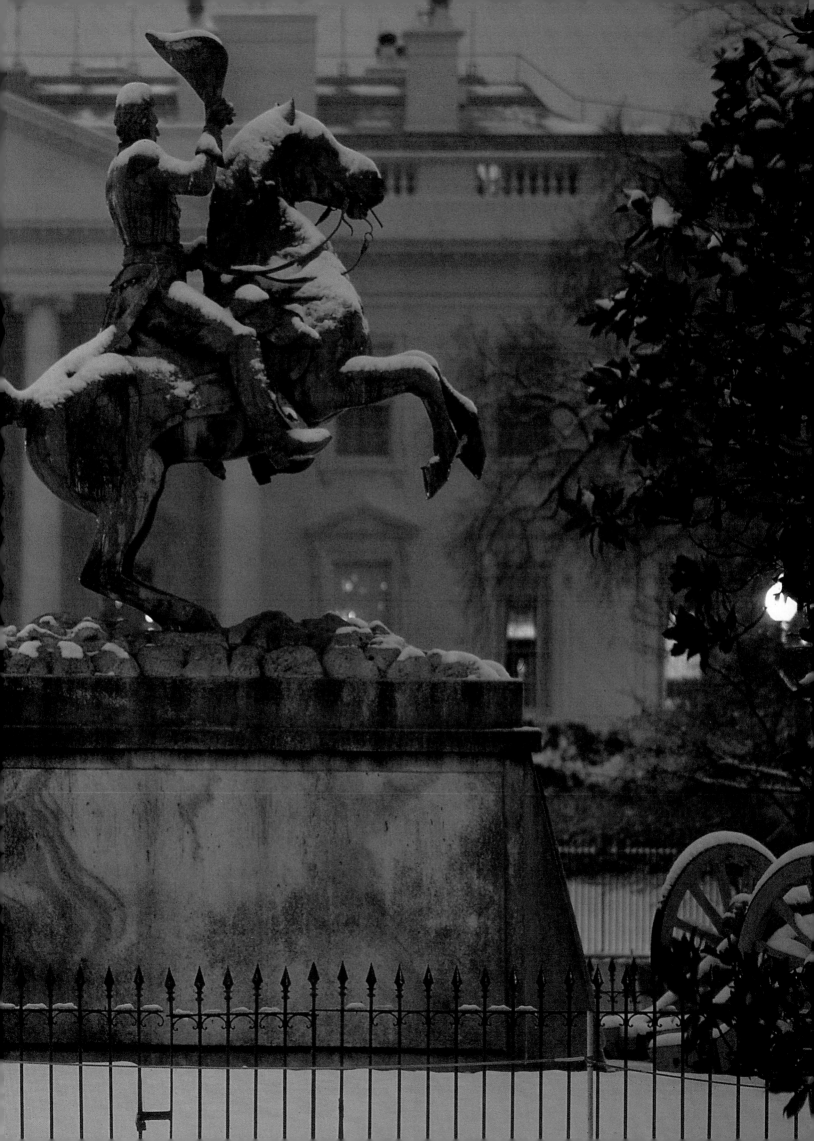

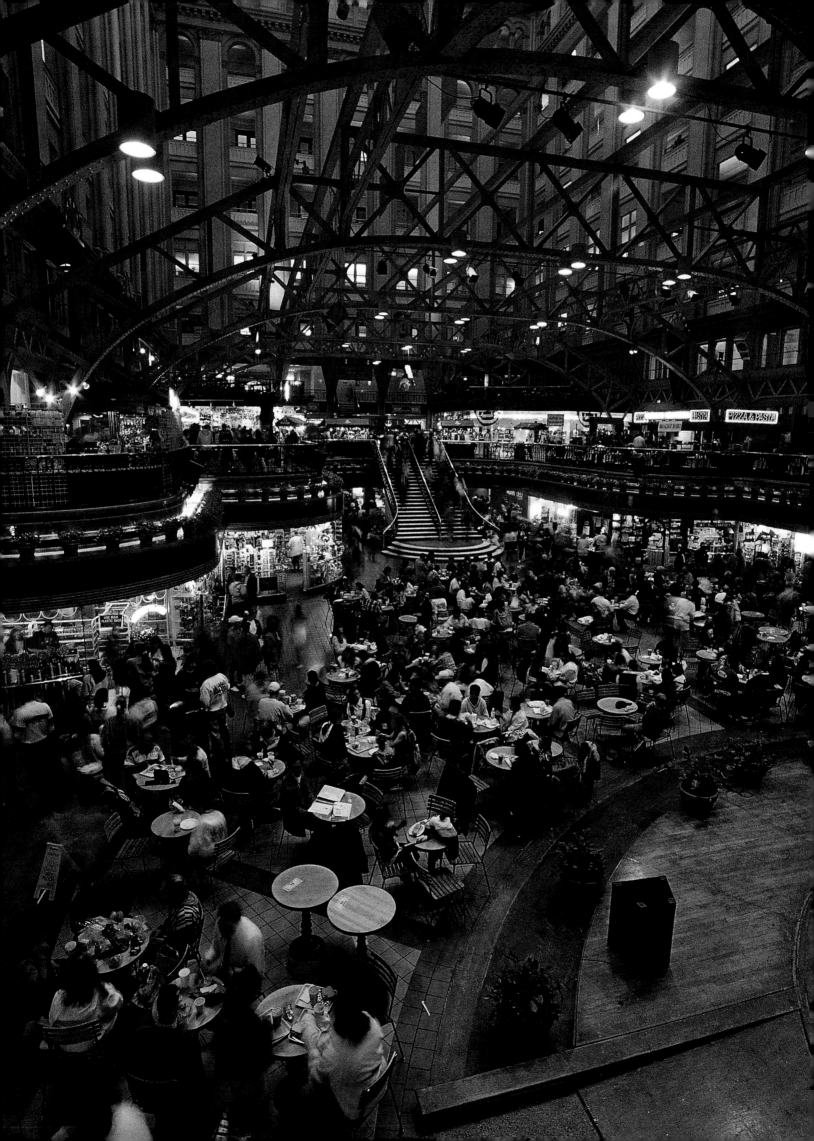

I was delighted with the whole aspect of Washington; light, cheerful, and airy, it reminded me of our fashionable watering-places."

Frances Trollope
19th-century English traveler

(left and above) The Old Post Office.

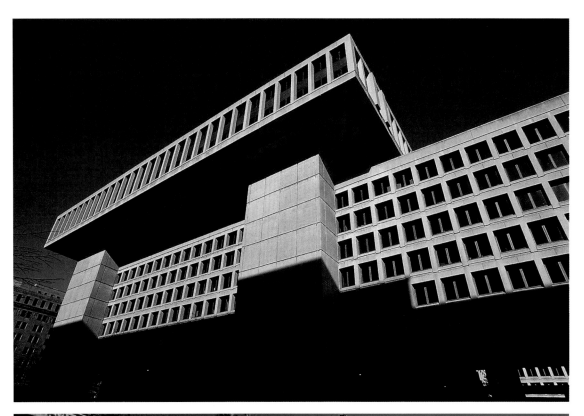

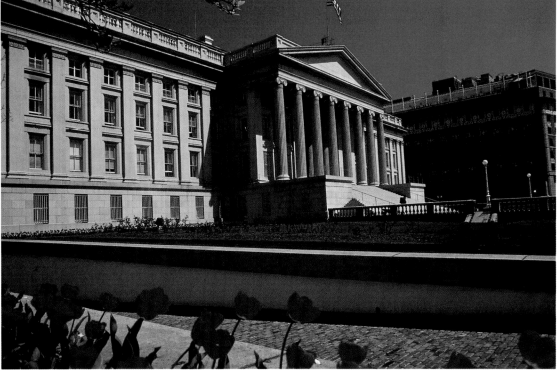

(top) FBI Building. **(bottom)** U.S. Treasury Building. **(right)** Controversial when built because of its French Empire design, the Old Executive Office Building originally housed the War, Navy, and State Departments.

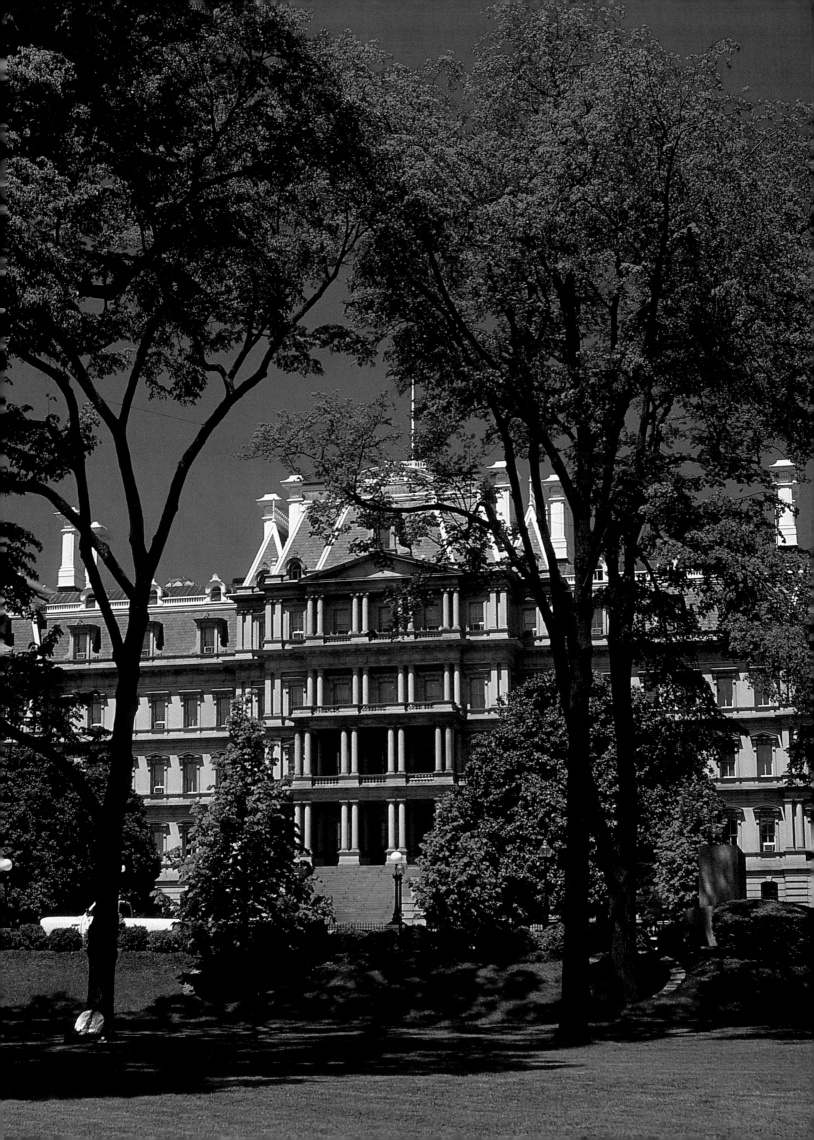

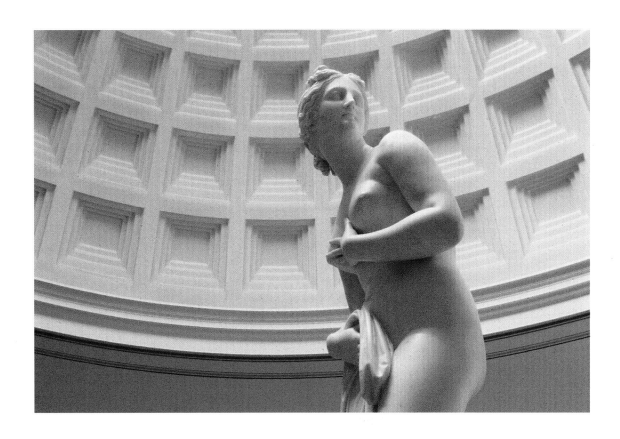

65 **(left and above)** Corcoran Museum of Art.

(overleaf) Renwick Gallery.

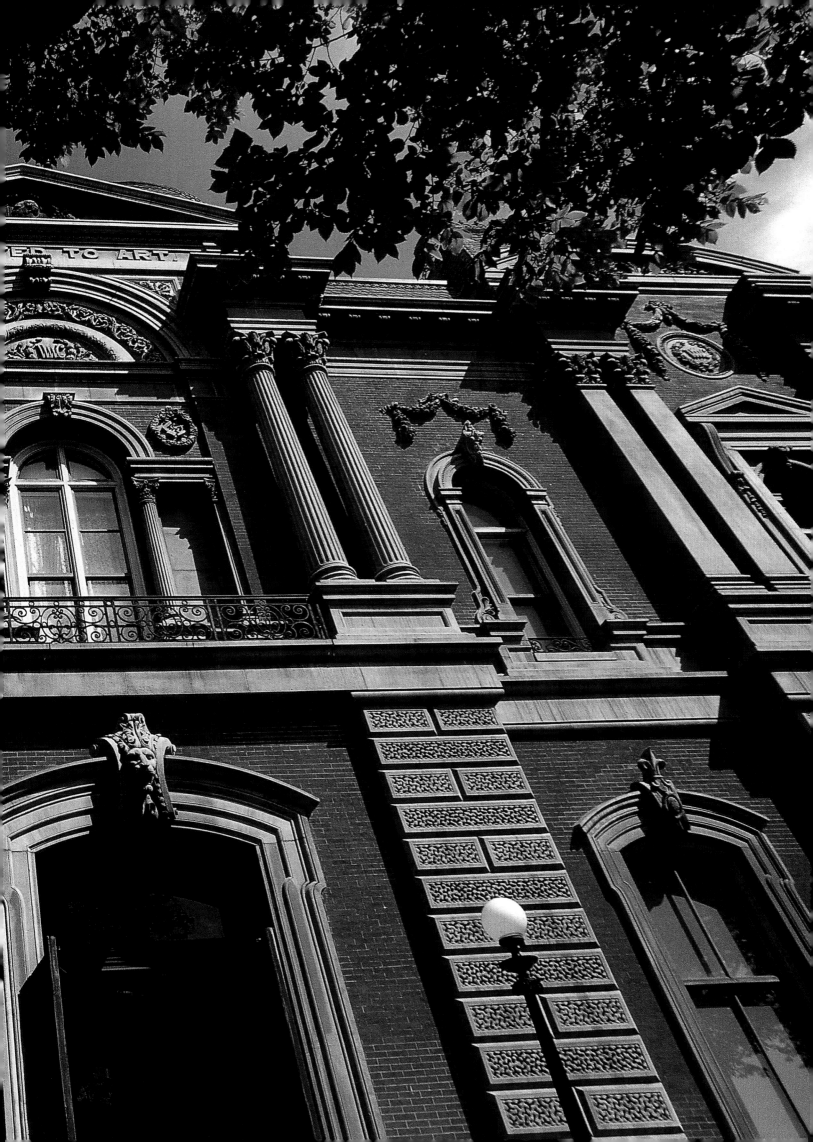

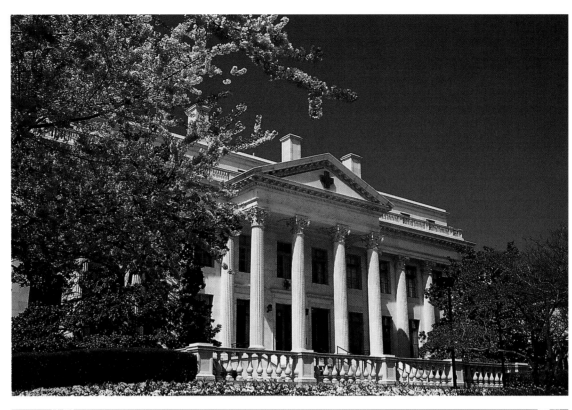

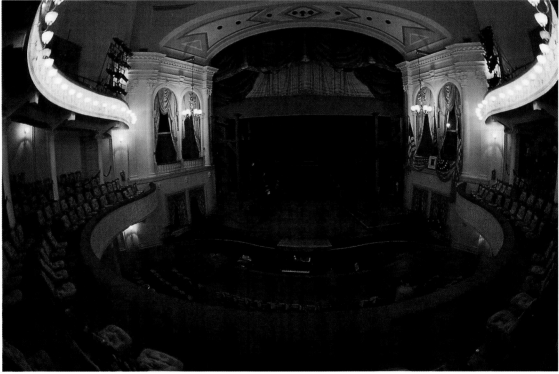

(top) The American Red Cross Building. **(bottom)** The Ford Theatre, interior. **(right)** The Octagon Museum. Shaped to conform to the patterns of the streets on which it is located, the Octagon House contains six sides and eight angles. Built in 1799–1801 as a private residence, it served as home to President and Mrs. Madison after the British burned the White House during the War of 1812. It is now a museum.

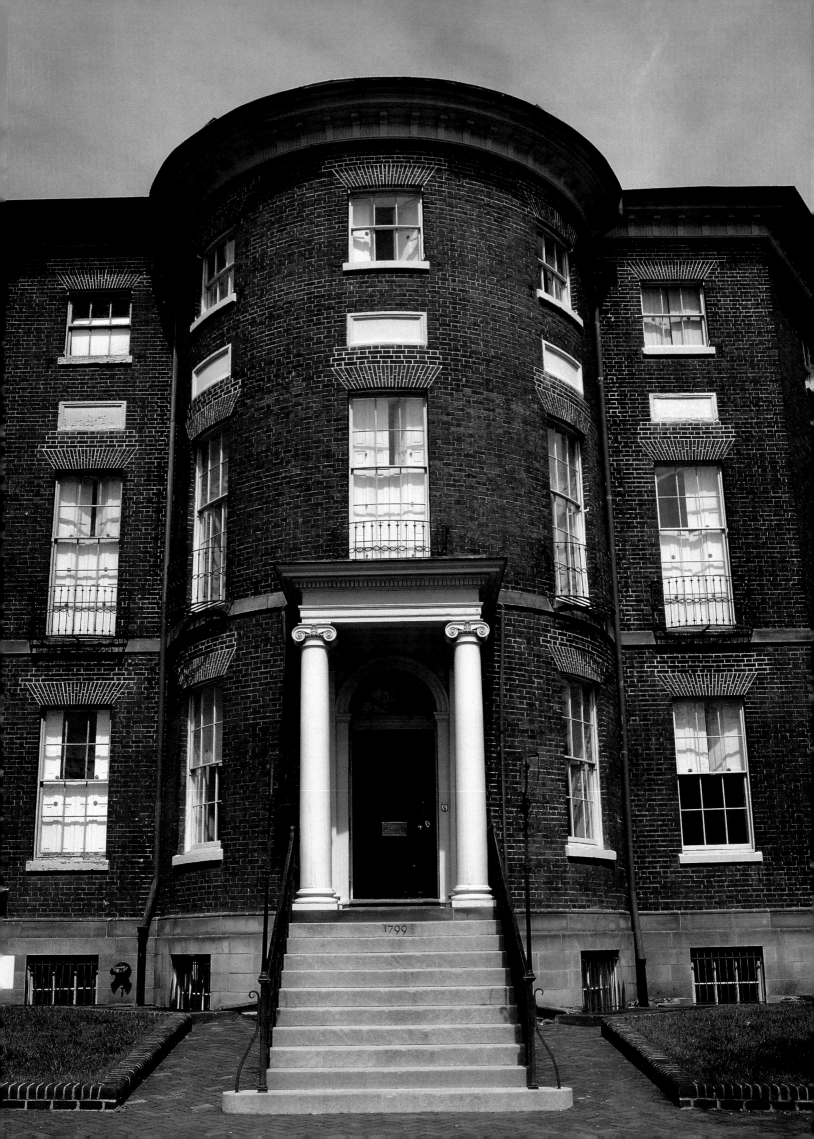

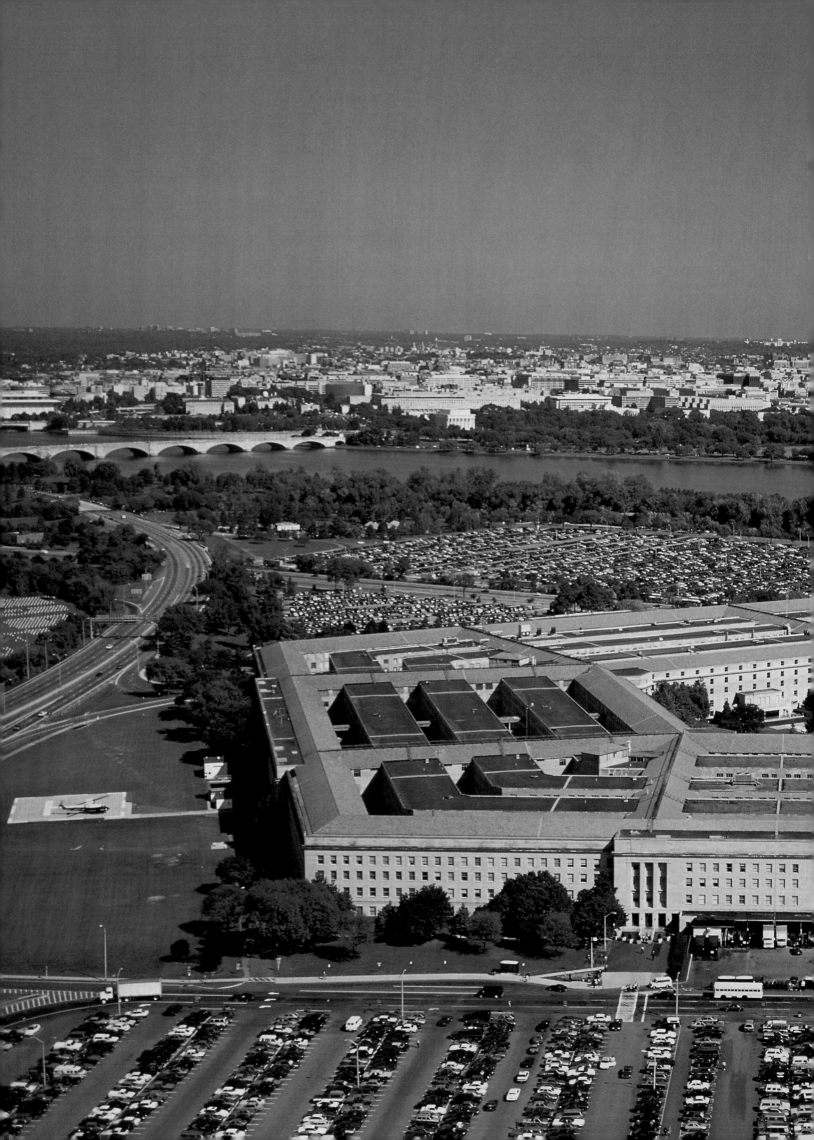

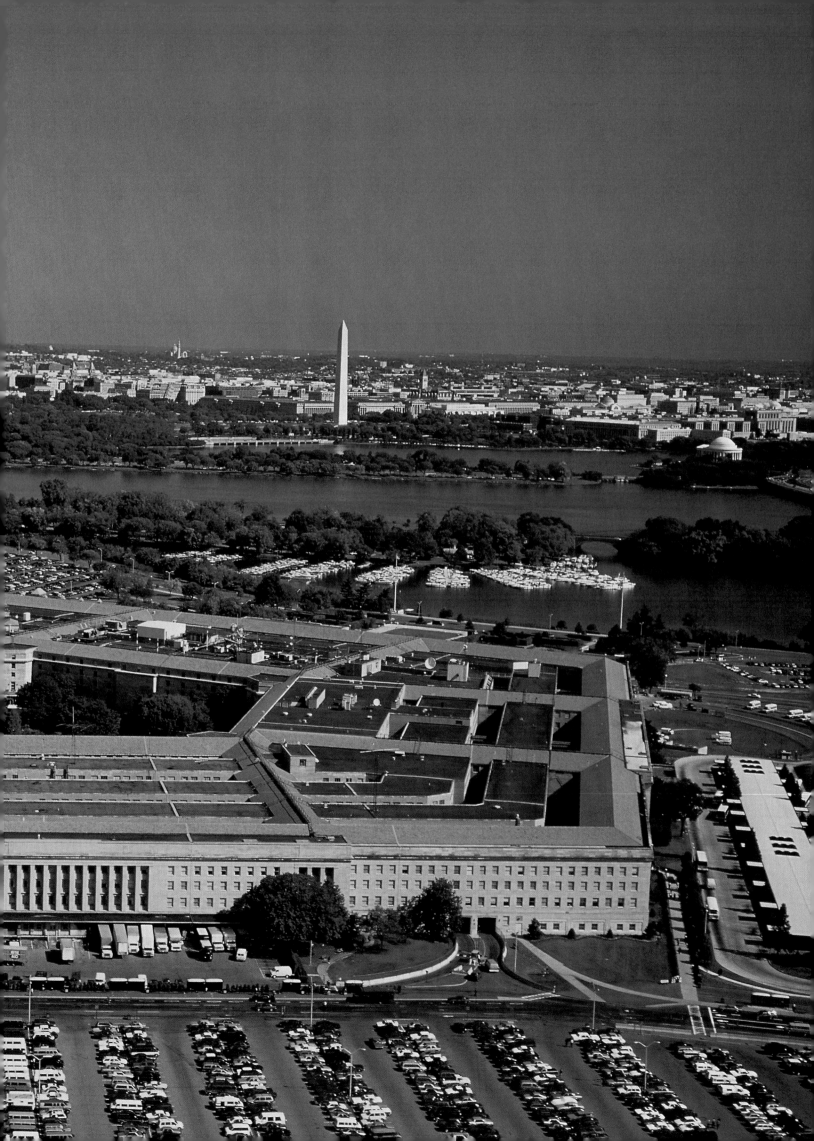

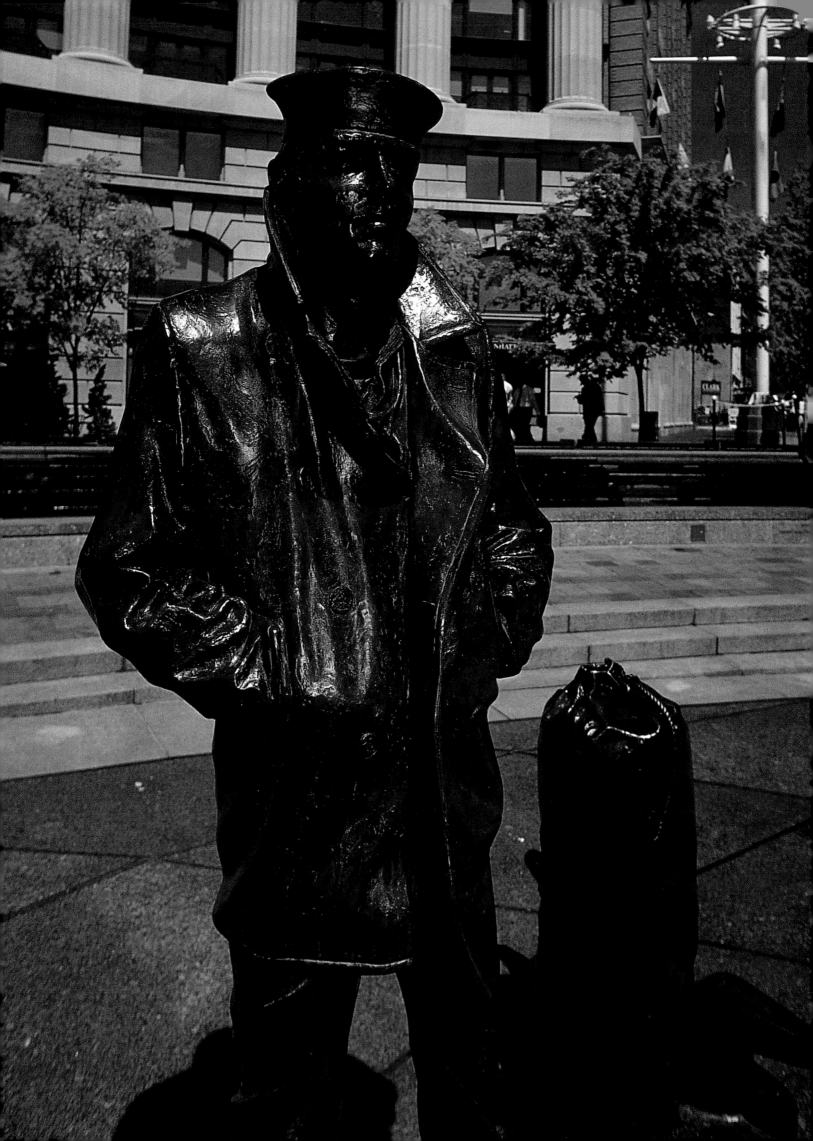

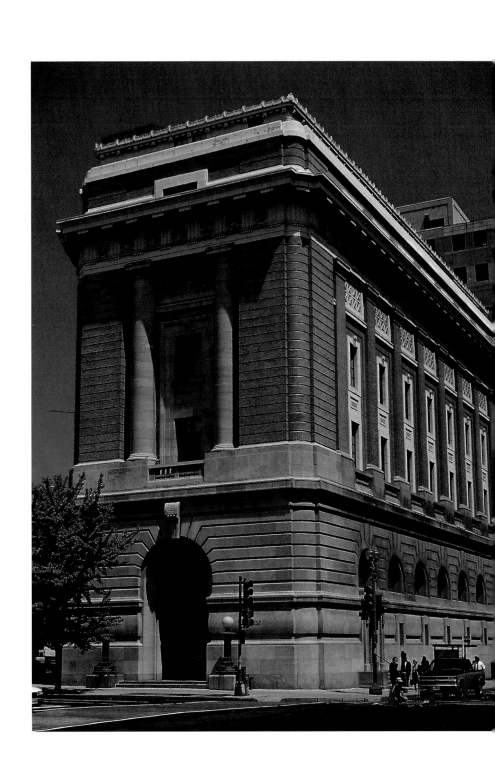

73 (previous overleaf) The Pentagon.

(left) U.S. Navy Memorial. (above) National Museum of Women's Arts.

(overleaf) National Building Museum and U.S. Patent Office.

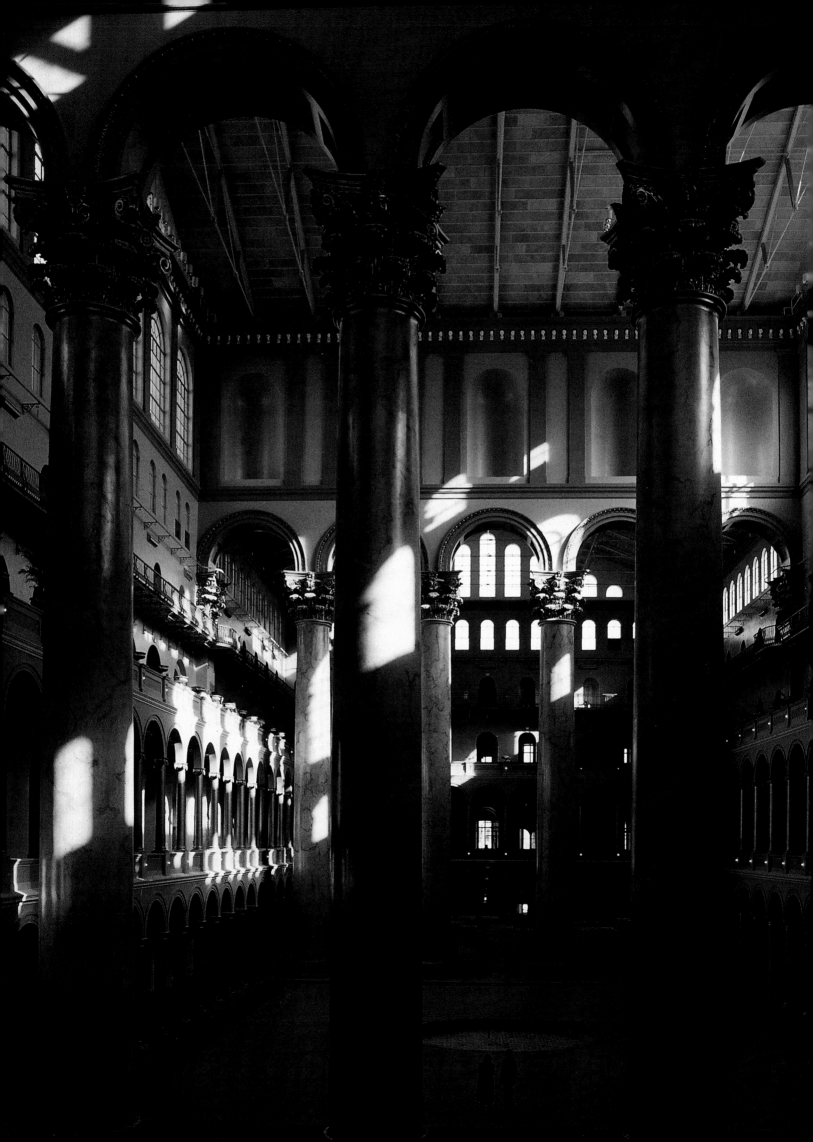

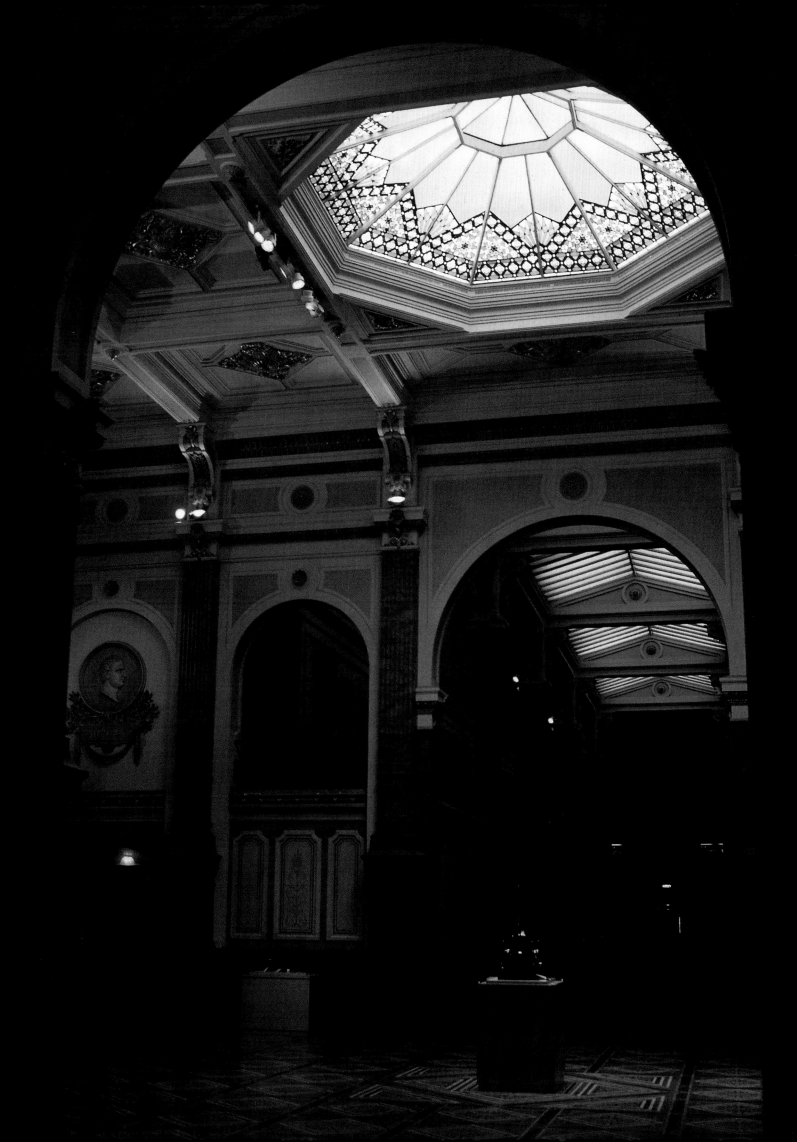

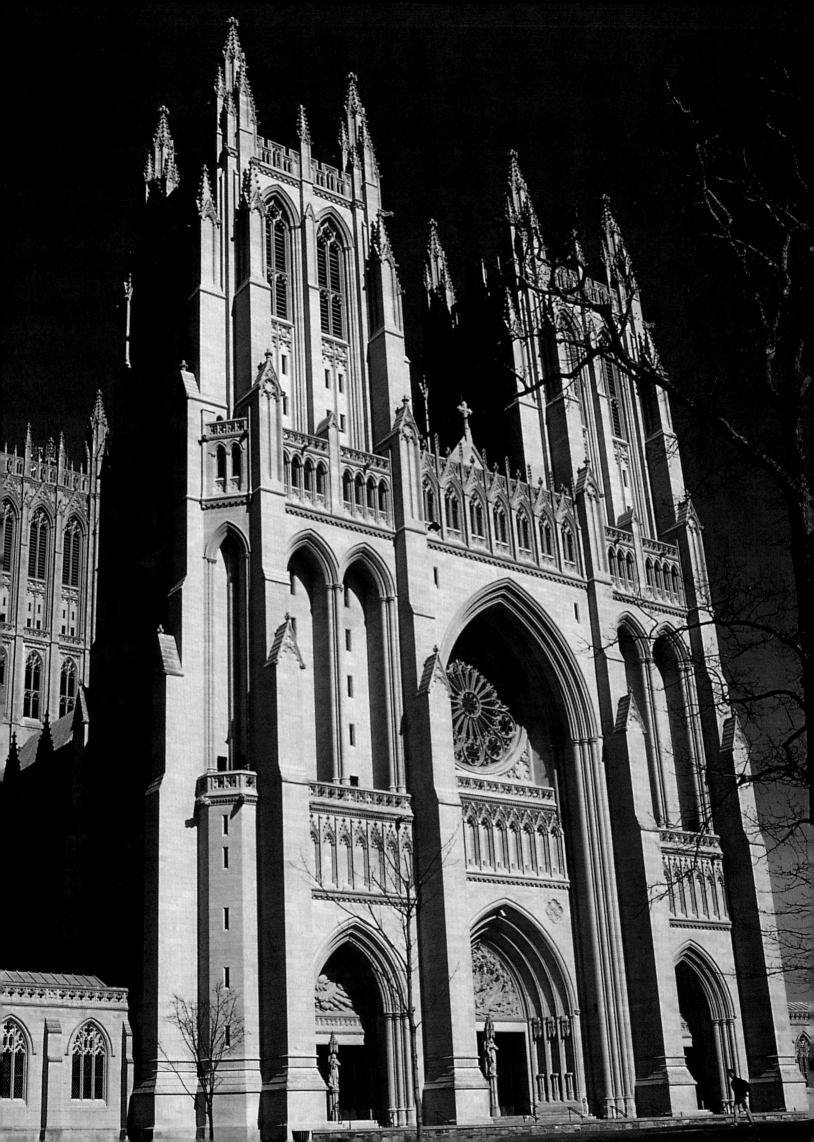

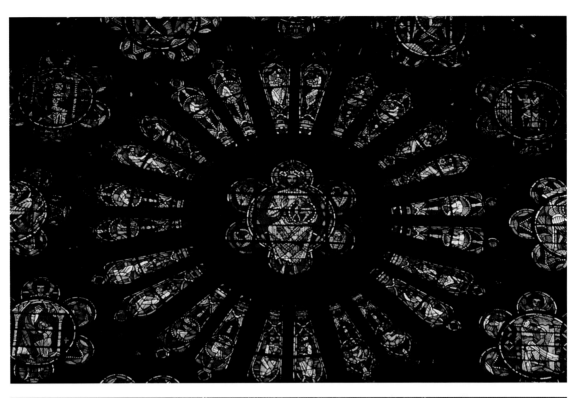

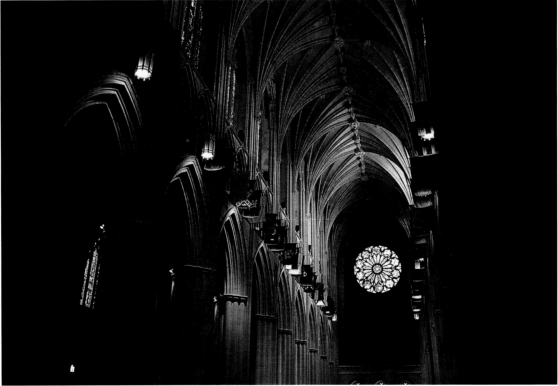

77 **(left, above and overleaf)** Construction of the Washington National Cathedral began in 1907 with Teddy Roosevelt officiat-
ing at the groundbreaking ceremony. It was completed and consecrated in 1990. The official name of the cathedral is the
Cathedral Church of St. Peter and St. Paul.

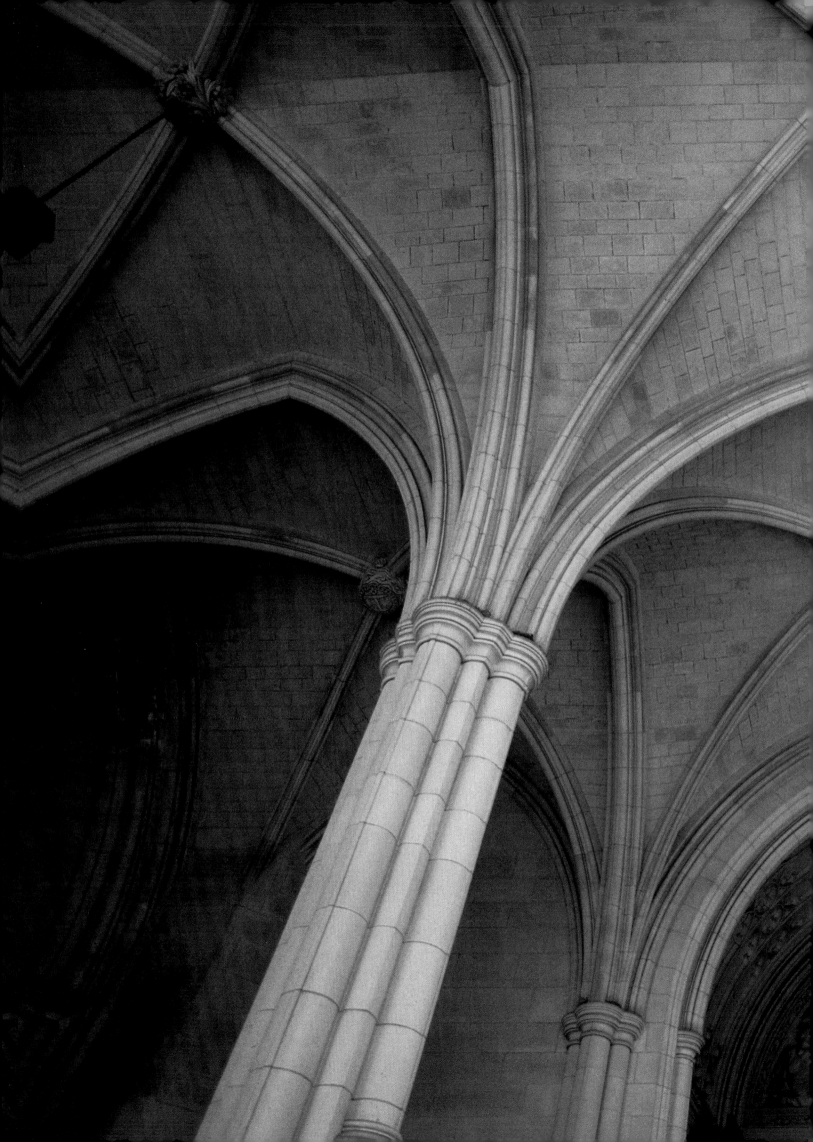

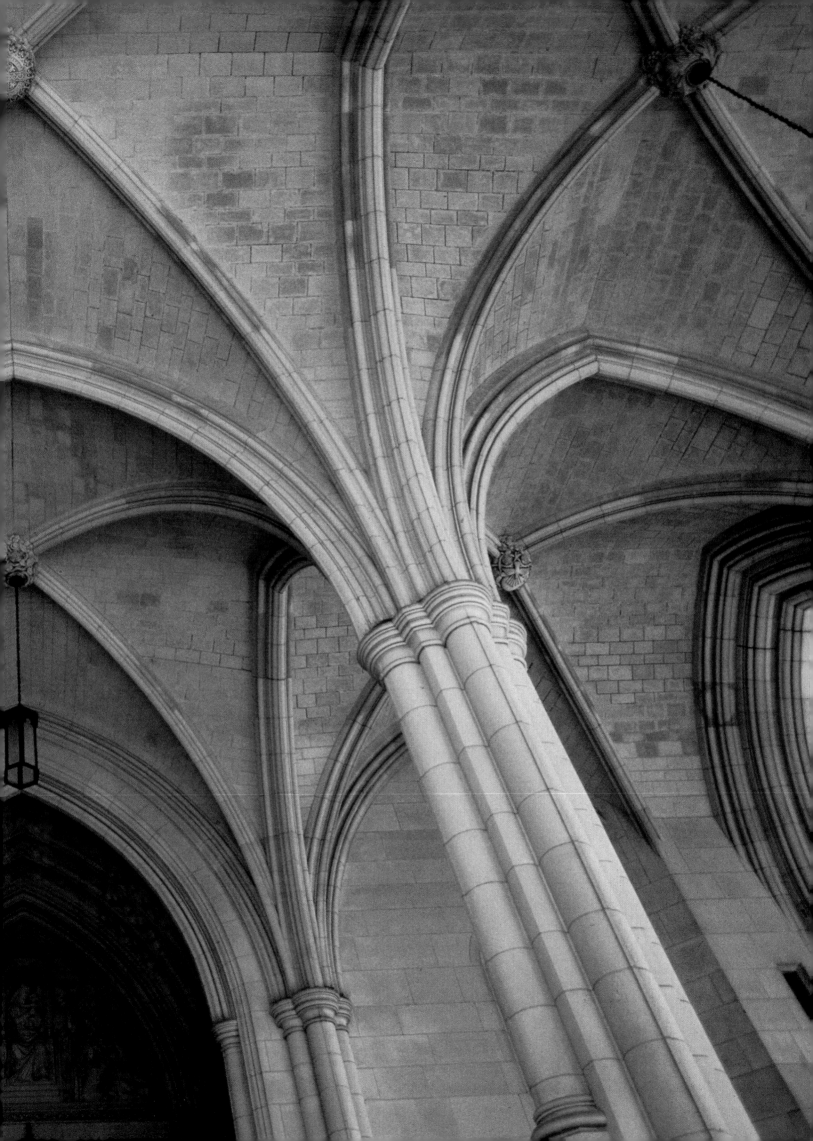

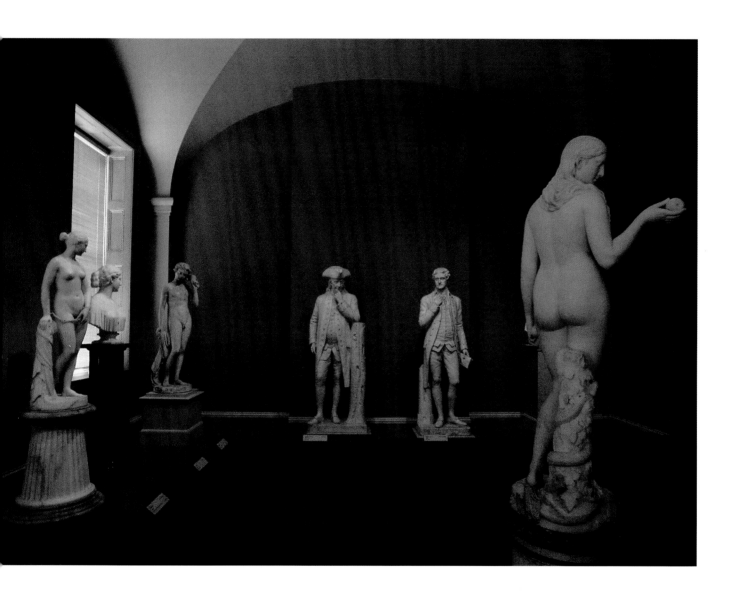

80 **(above and right)** National Museum of American Art.

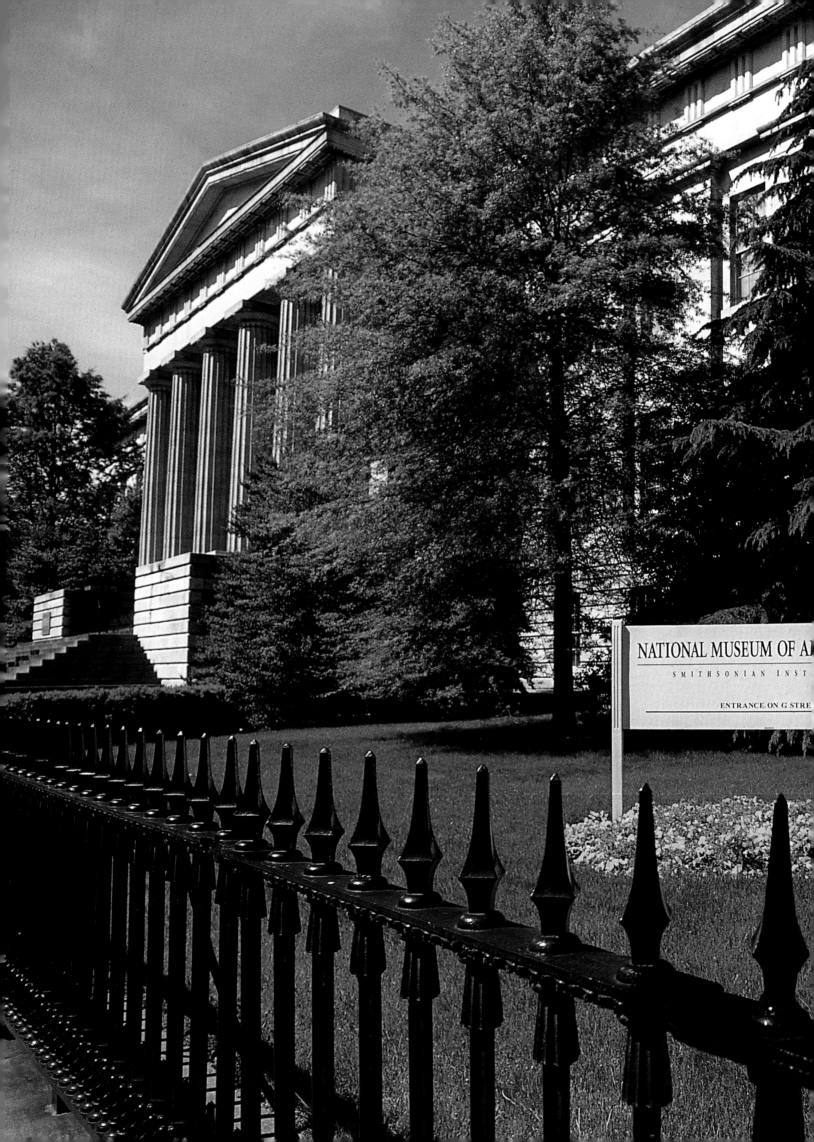

NATIONAL MUSEUM OF A[...]

SMITHSONIAN INST[...]

ENTRANCE ON G STRE[...]

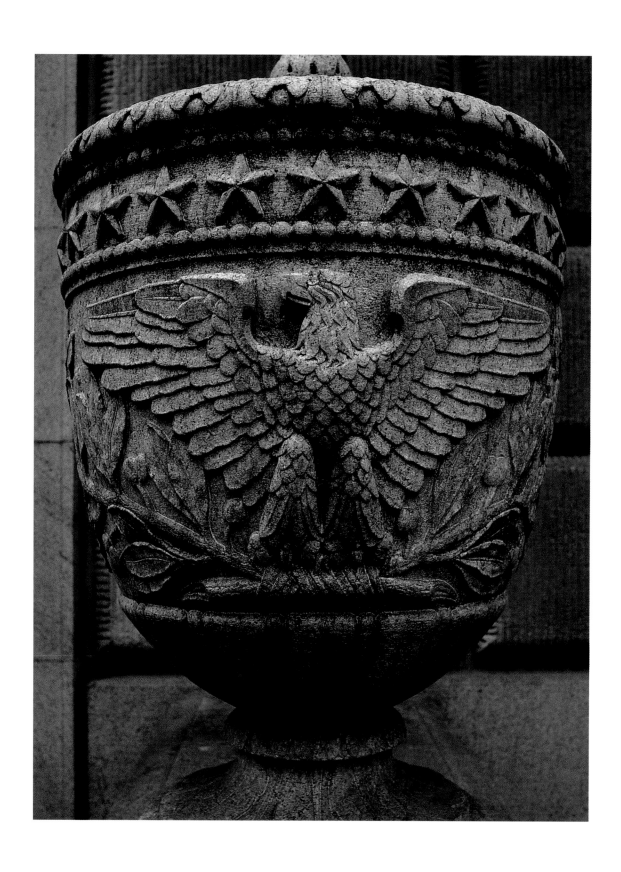

83 **(left)** Department of Commerce. **(above)** Department of Commerce, Stone Urn.

(overleaf) Center for Performing Arts.

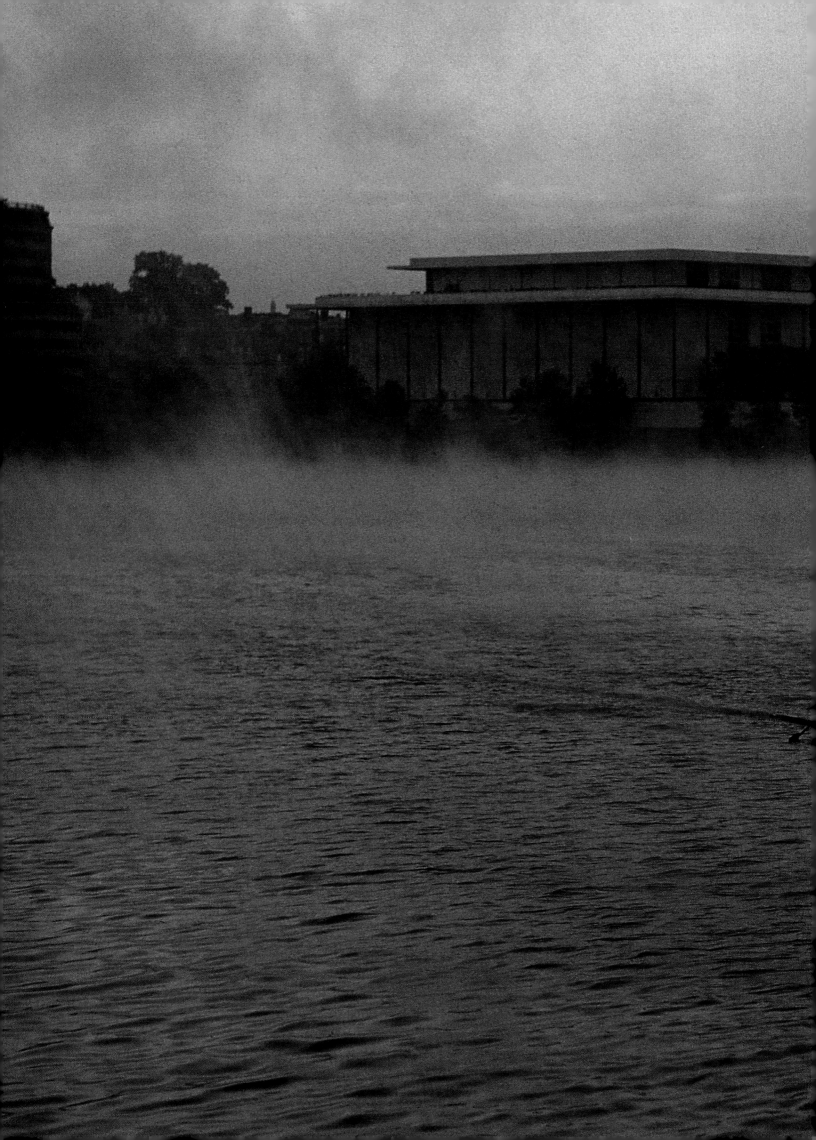

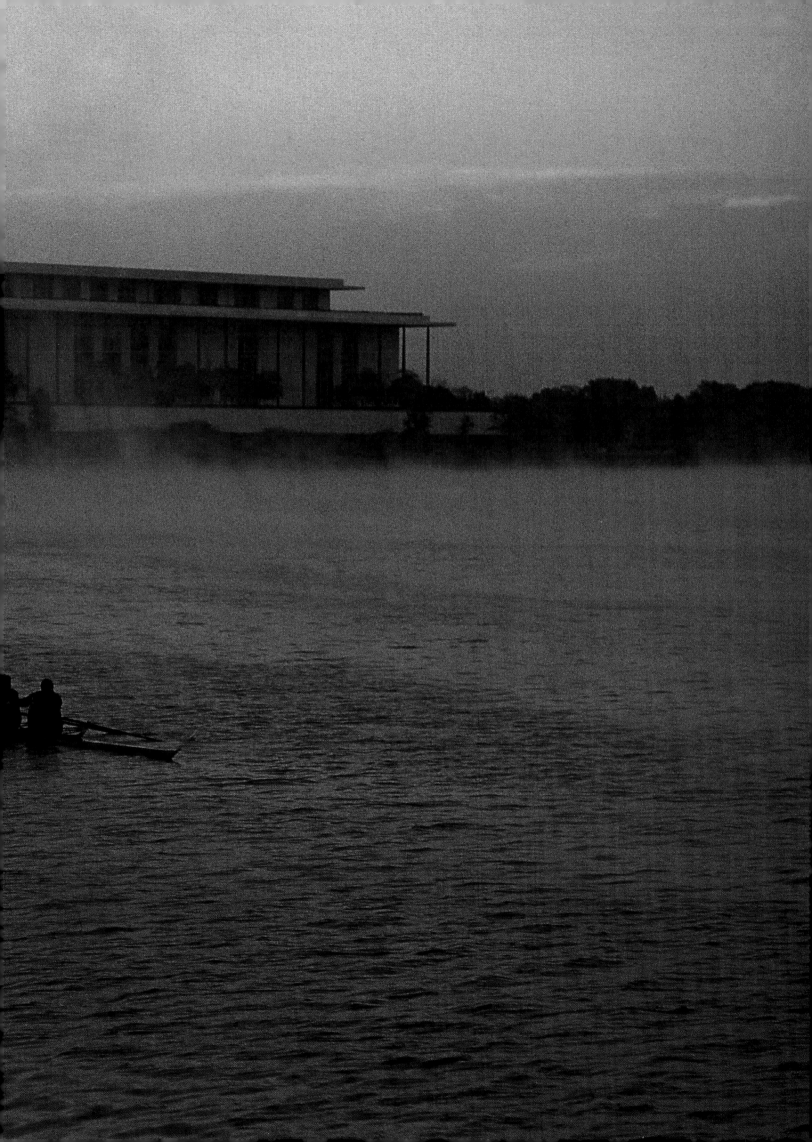

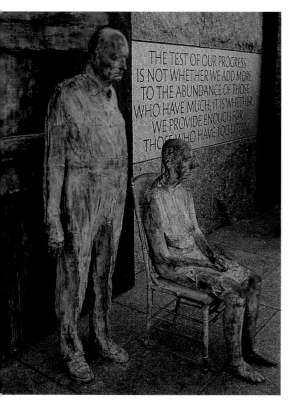

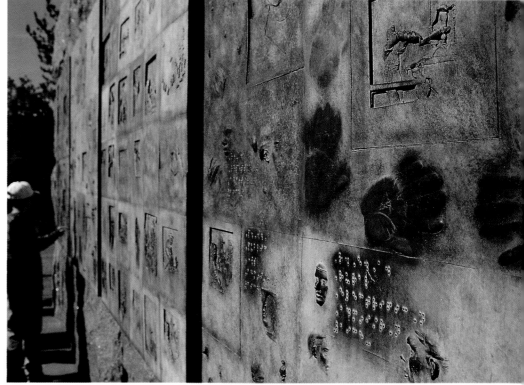

86 **(left, right, and far right)** The FDR Monument.

(overleaf) The Willard Hotel and the Canadian Embassy. The Willard Hotel has been enlarged, destroyed, rebuilt, and renovated in the hundred-plus years of its existence. When the hotel was renovated in 1984, the Secret Service and the State Department helped design the sixth floor, where foreign dignitaries are lodged.

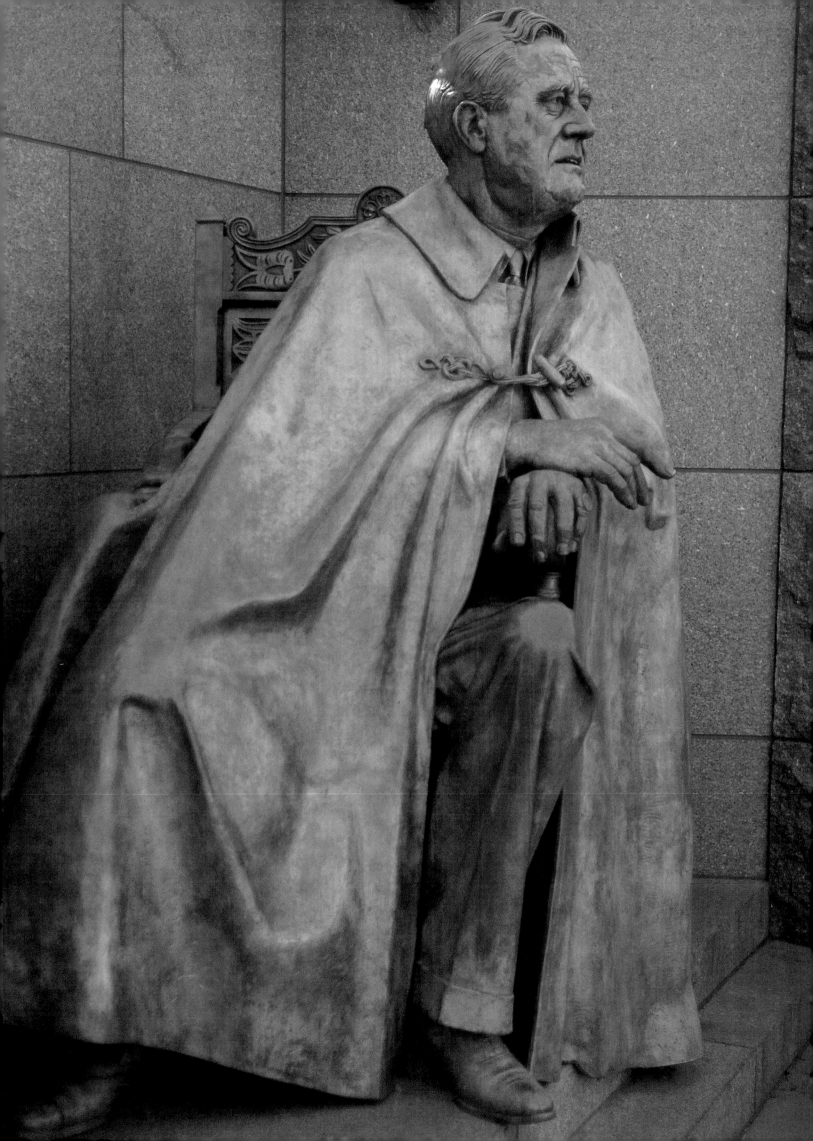

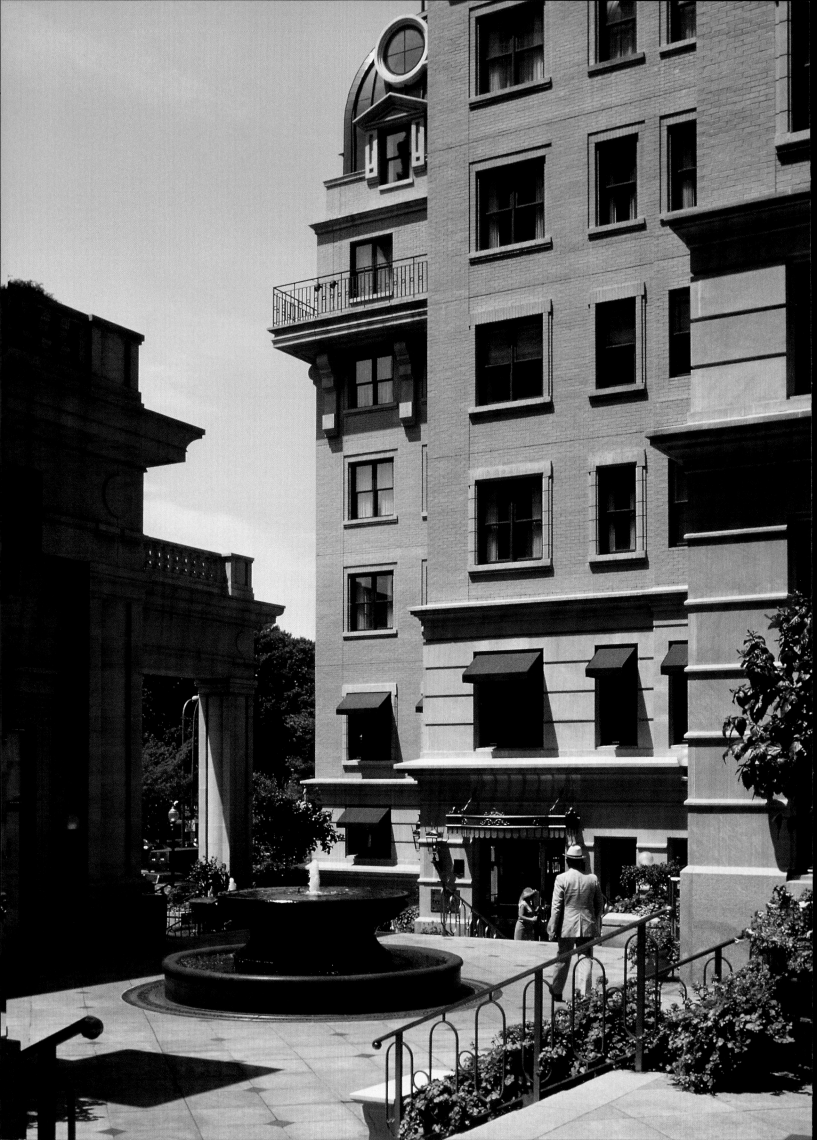

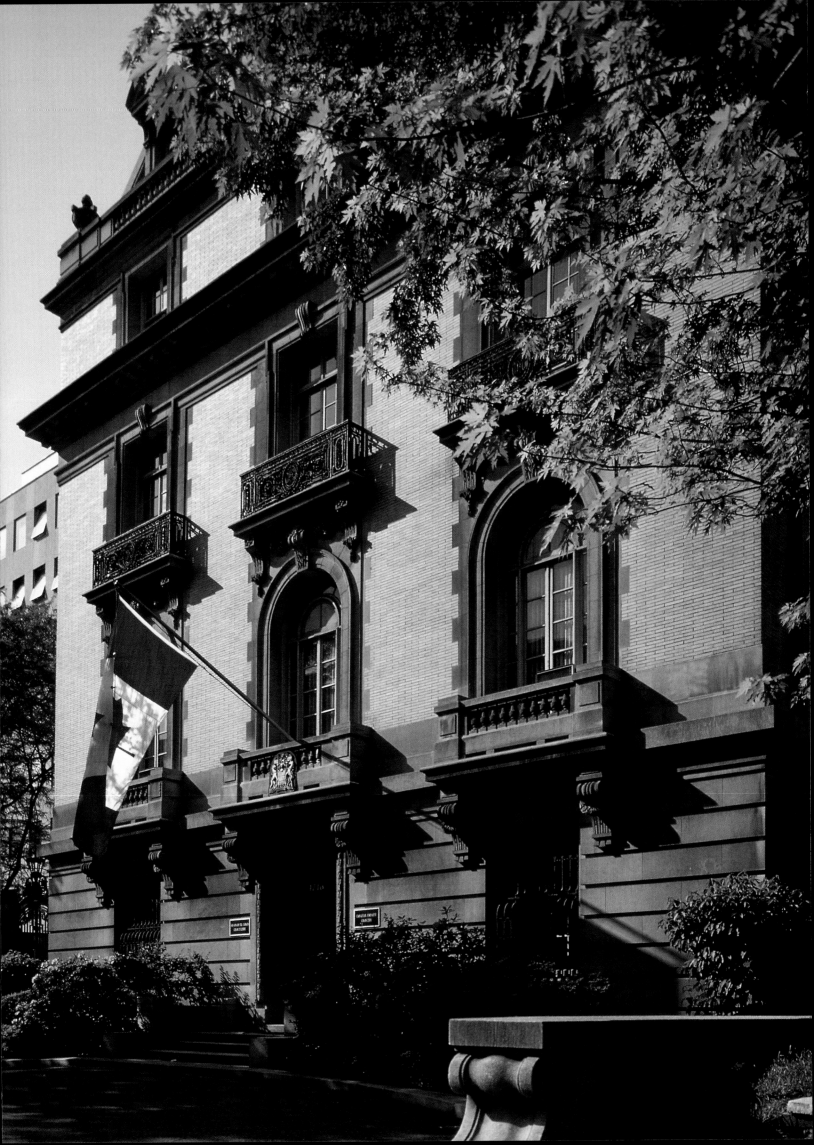

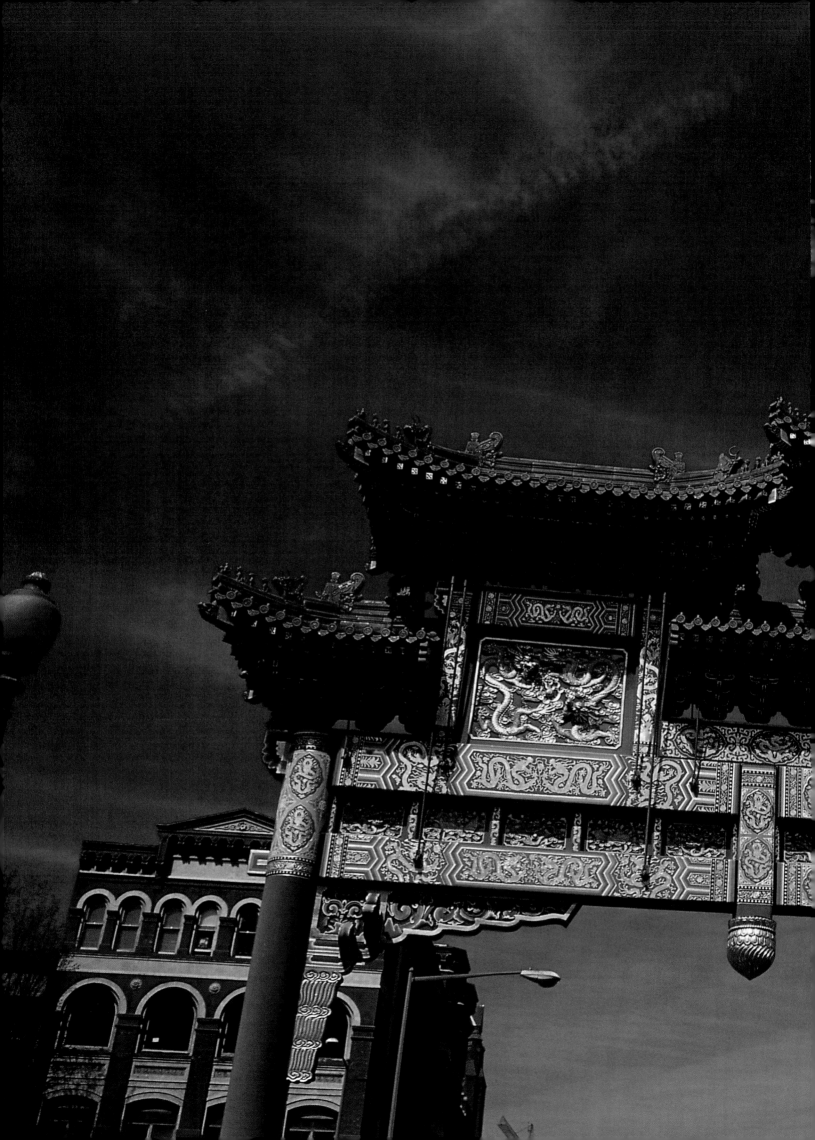

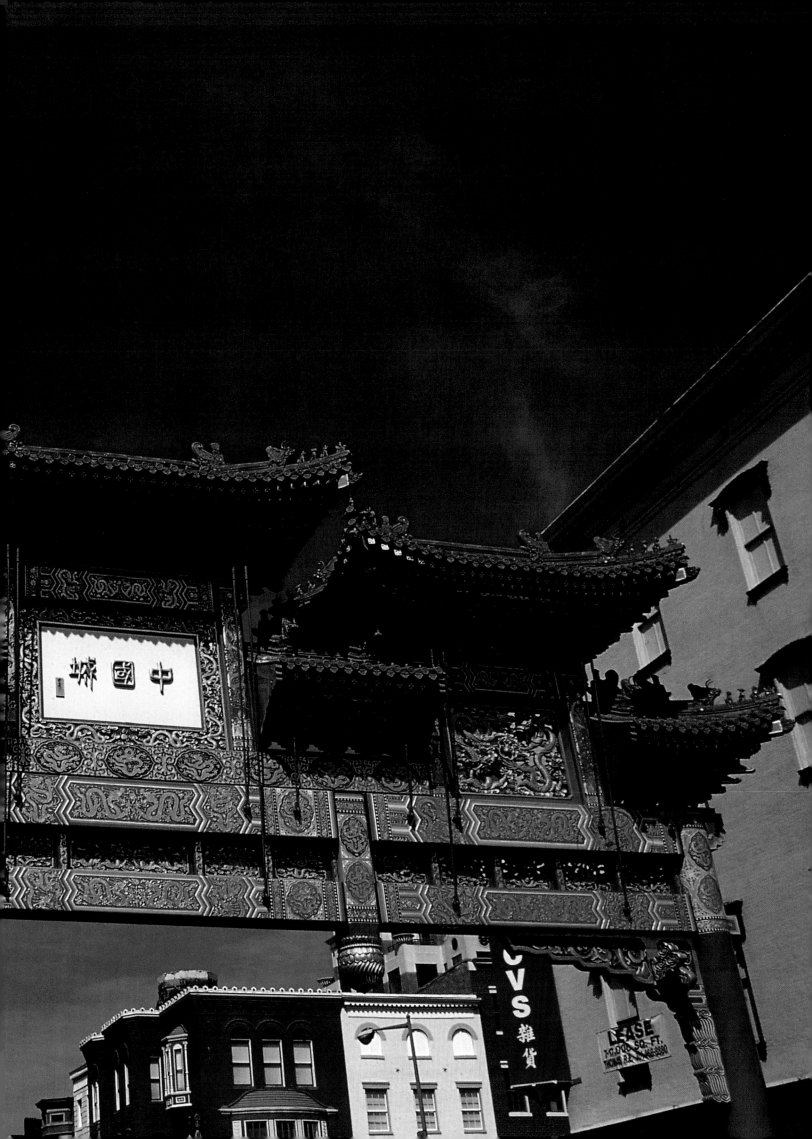

93 **(previous overleaf)** China Town.

(above and left) The Waterfront Seafood Market.

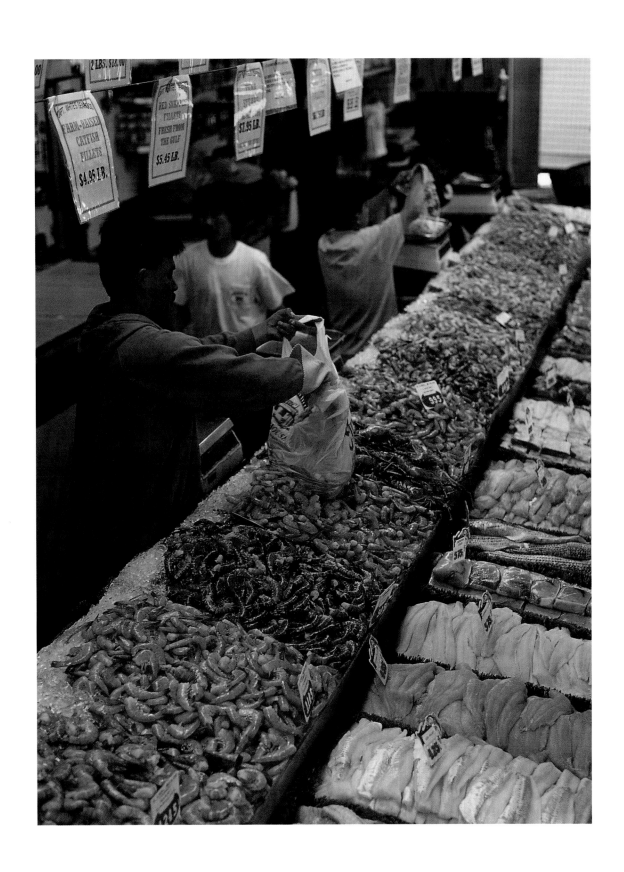

93 **(previous overleaf)** China Town.

(above and left) The Waterfront Seafood Market.

W

ashington is a city of southern efficiency

and northern charm."

John F. Kennedy (1917–1963)
American president

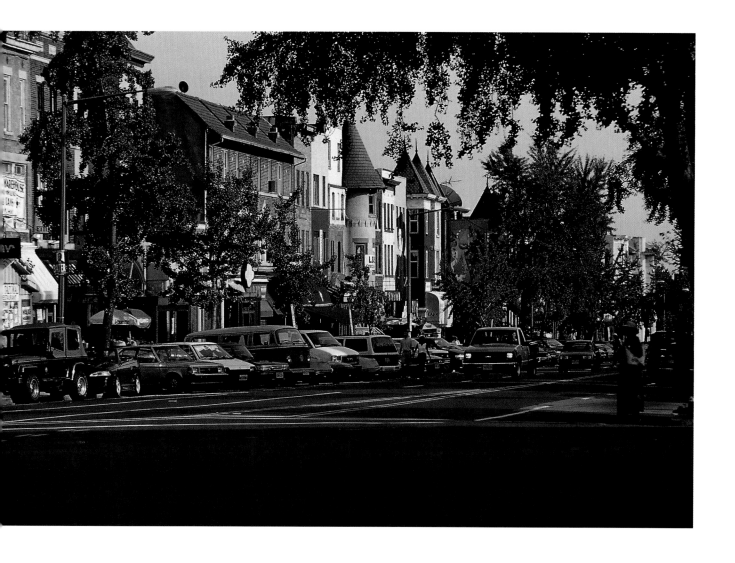

94 **(above and right)** Adams-Morgan is Washington's most ethnically diverse neighborhood. International restaurants, funky
boutiques, and bohemian residents make it comparable to Manhattan's Greenwich Village.

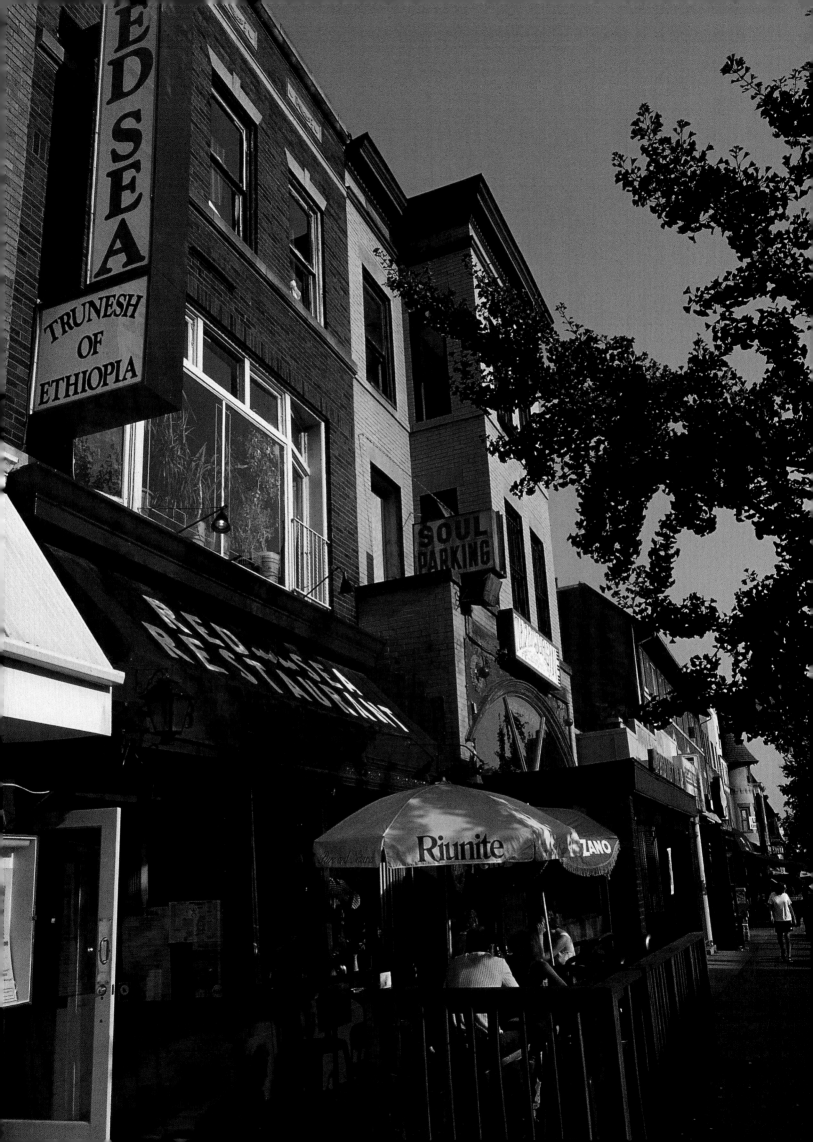

(previous overleaf) Rock Creek Park in the Fall.

(above) Pierce Mills. **(right)** Rock Creek Park in the Winter.

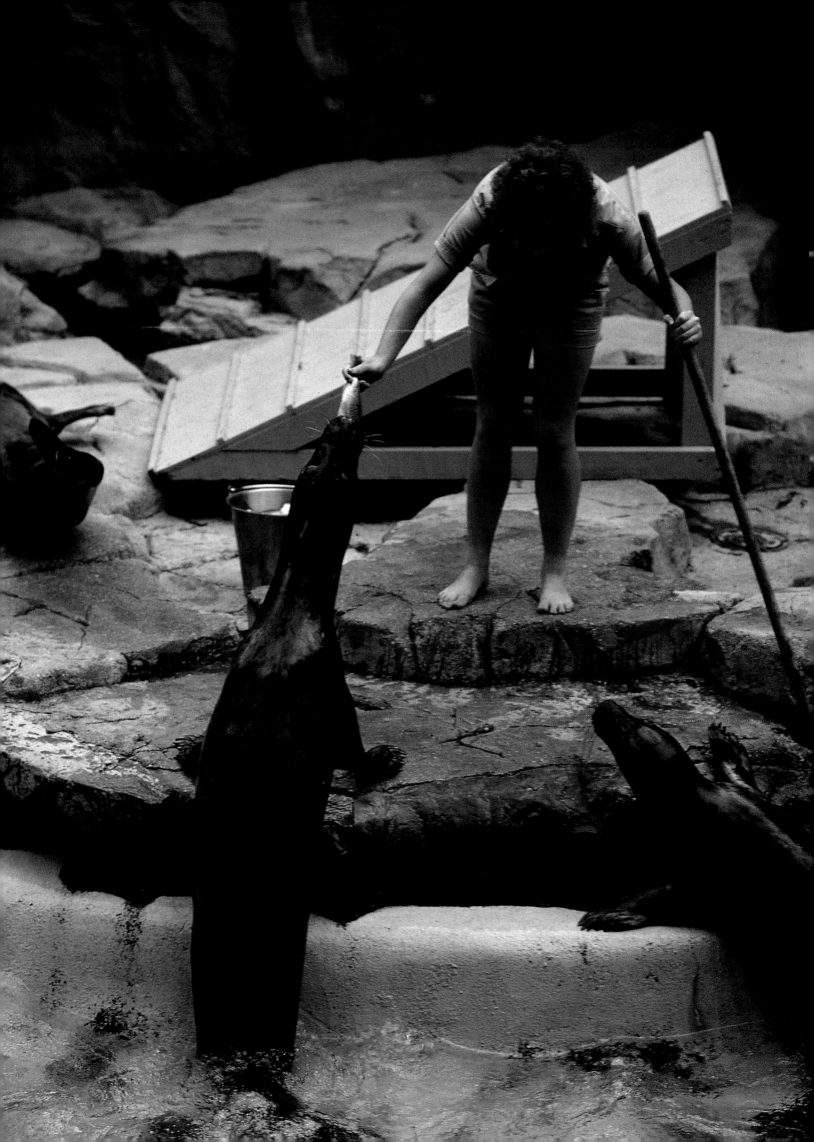

101 **(left, above, and overleaf)** The Zoo.

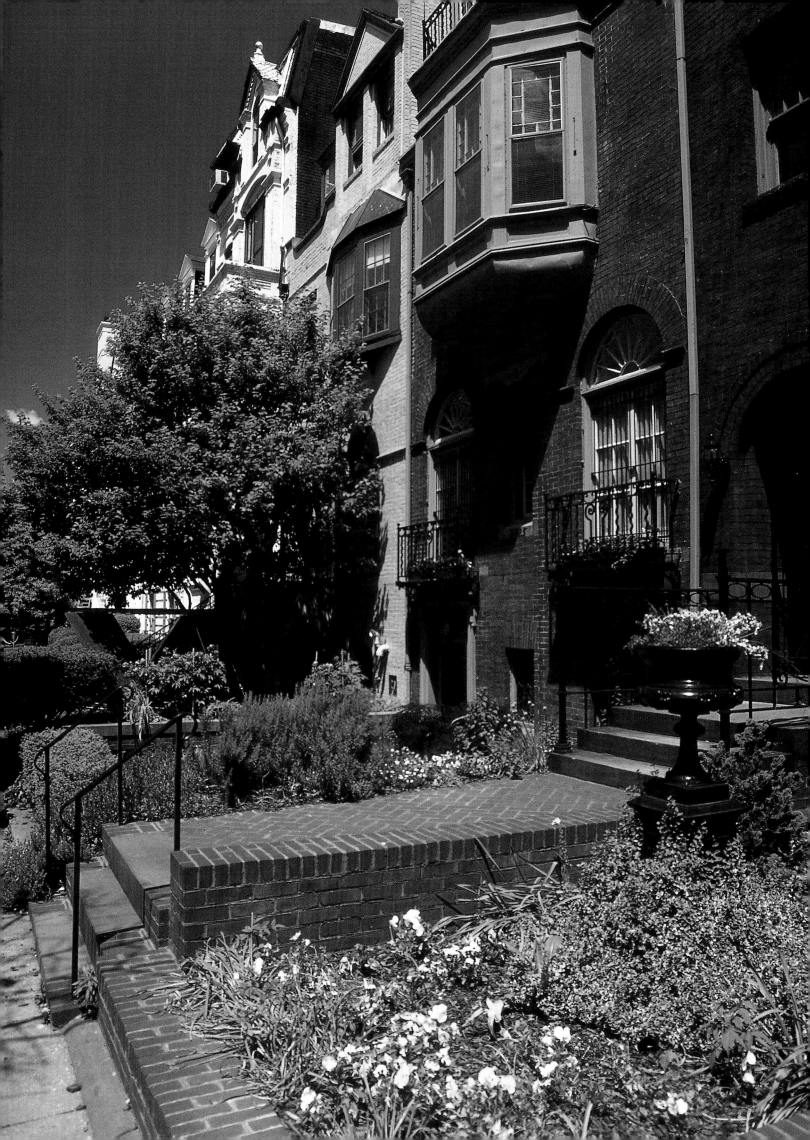

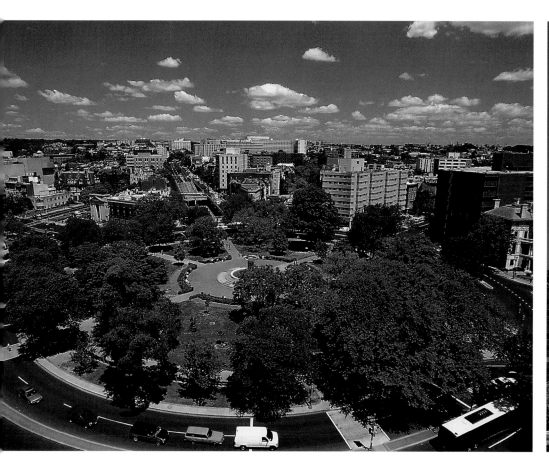

105 **(far left)** Dupont Circle, Q Street. **(left)** New York Avenue Presbyterian Church. **(right)** Dupont Circle, overhead.

(overleaf) The National Geographic Building.

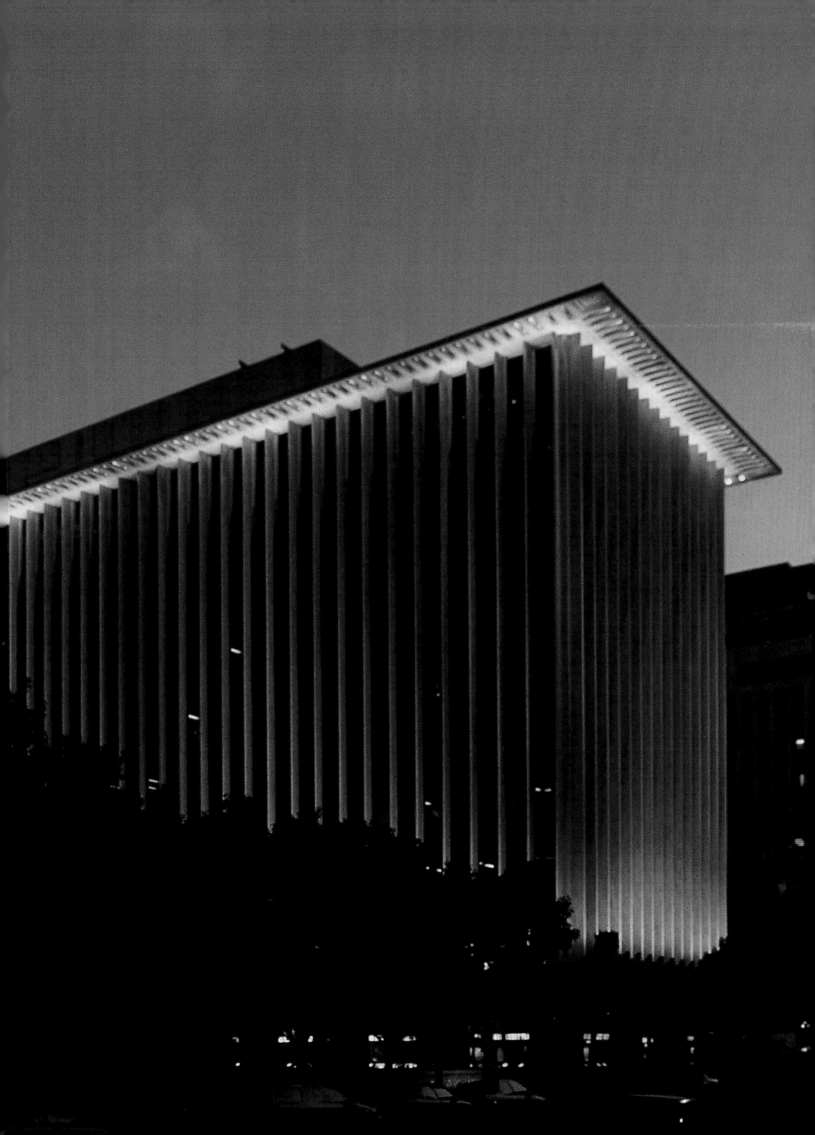

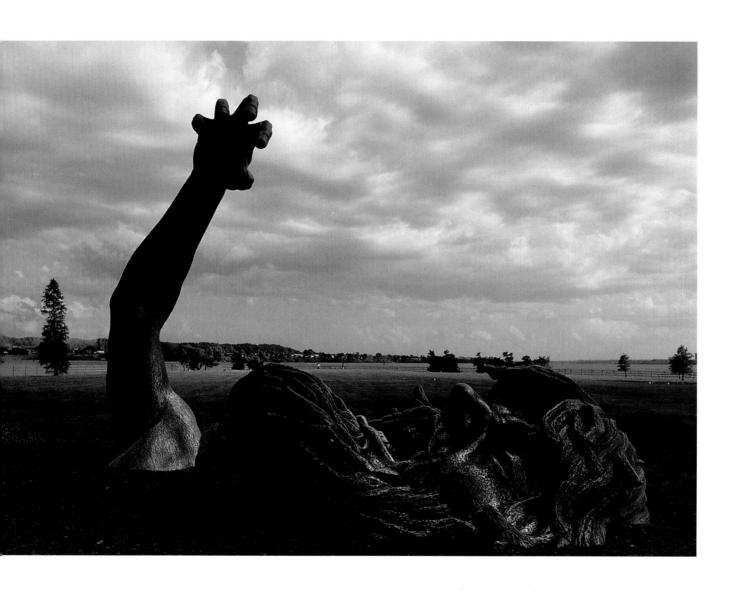

The Potomac and the
Anacostia seem to hold the city
in their
grasp, like a kite resting in the
crook of a tree."
John F. Ross

108 **(above and right)** Haines Point.

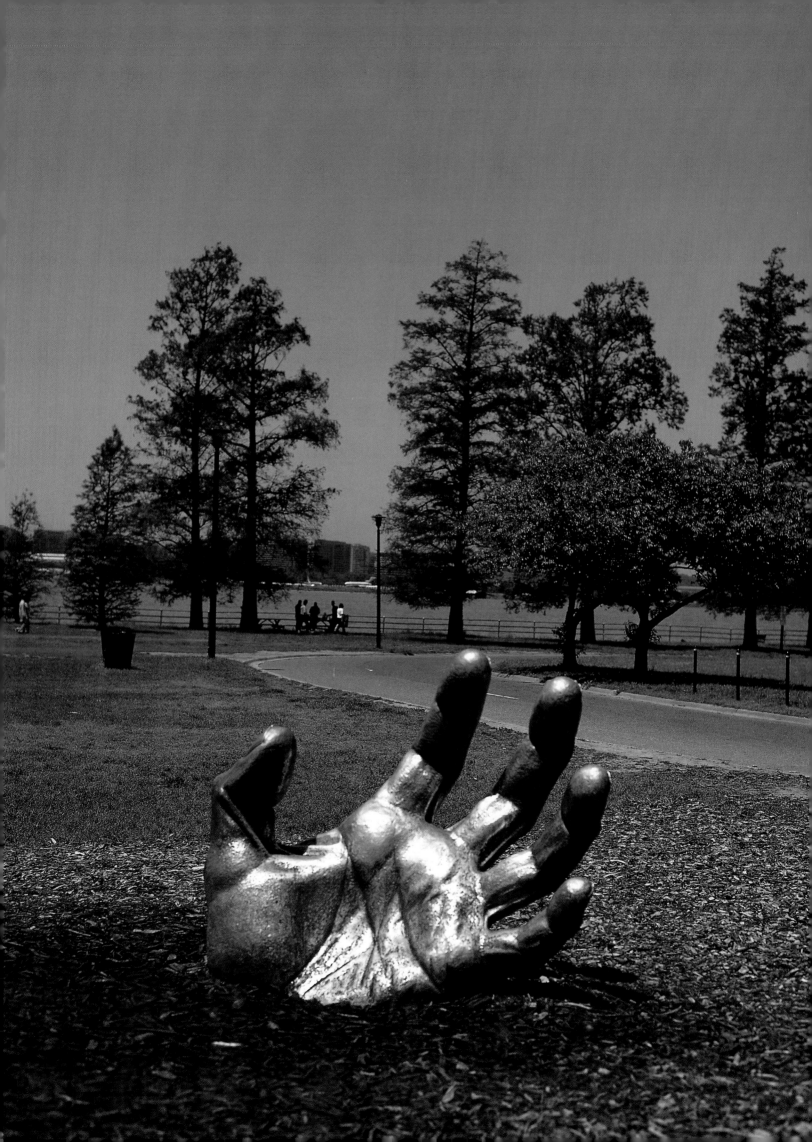

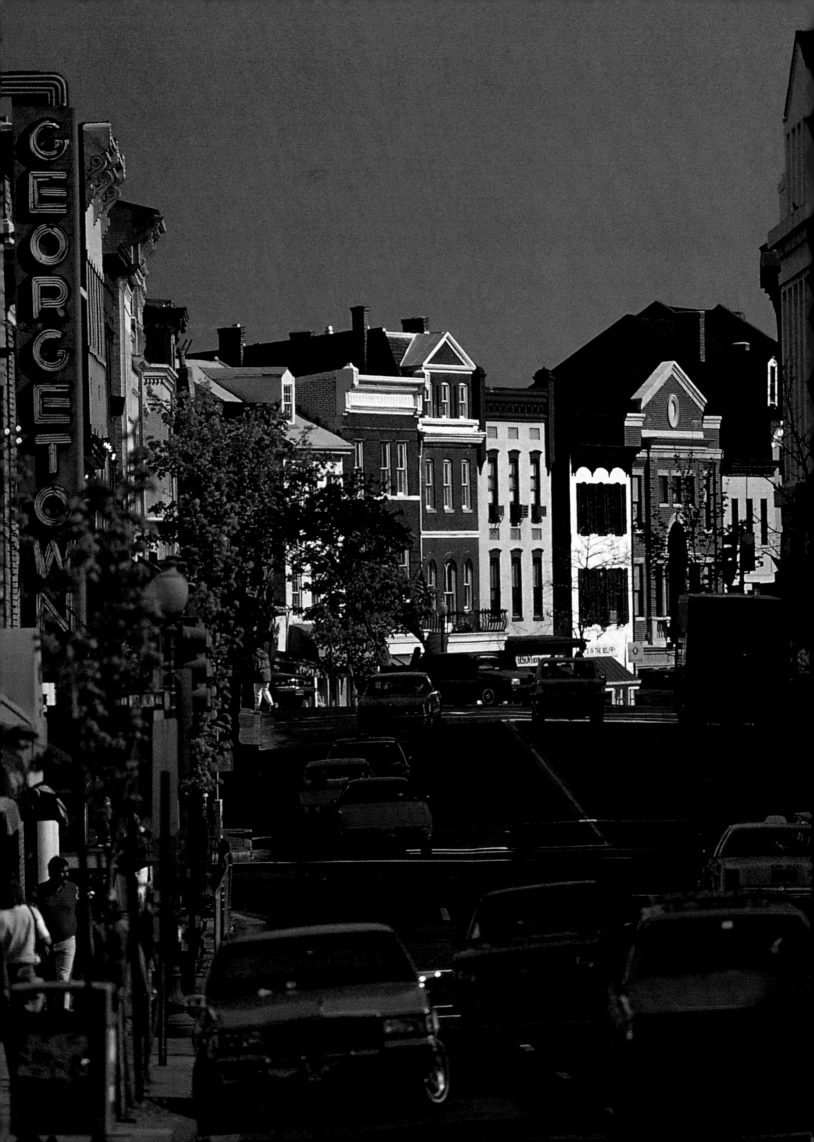

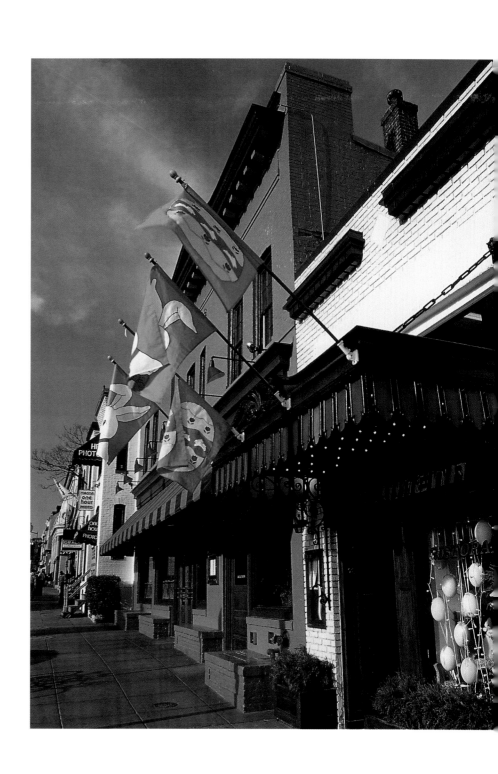

111 **(left and above)** Georgetown, Wisconsin Avenue.

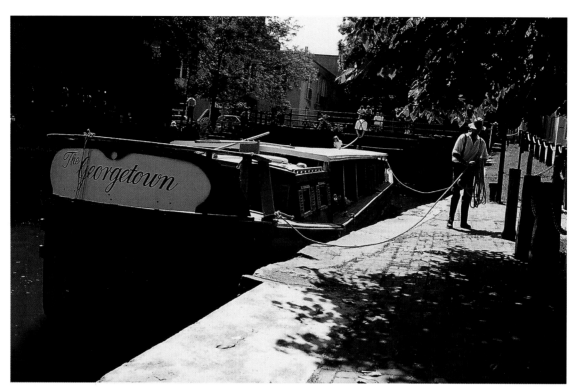

N
o matter how much one knows about Washington, there's always more to know. And then there are those things that one once knew, and—exasperatingly—forgot."

Elizabeth Drew
20th-century American journalist

(above) C&O Canal. **(right)** Georgetown University.

(overleaf) P Street homes.

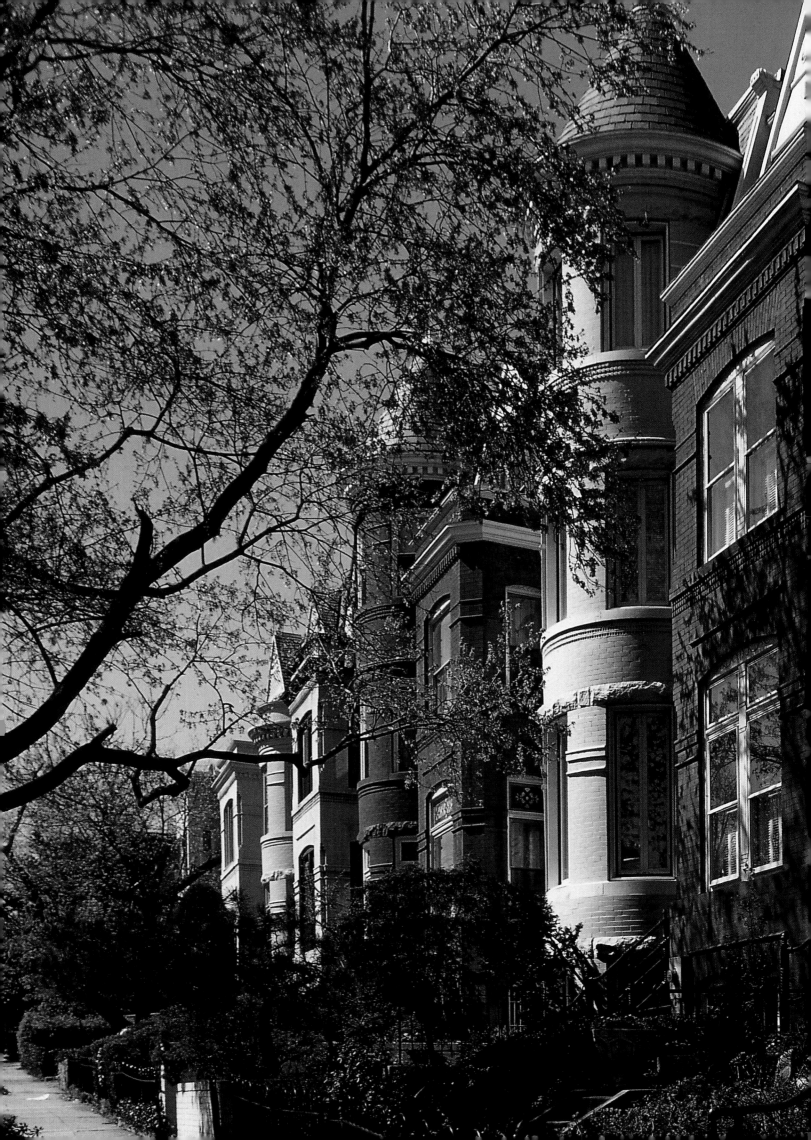

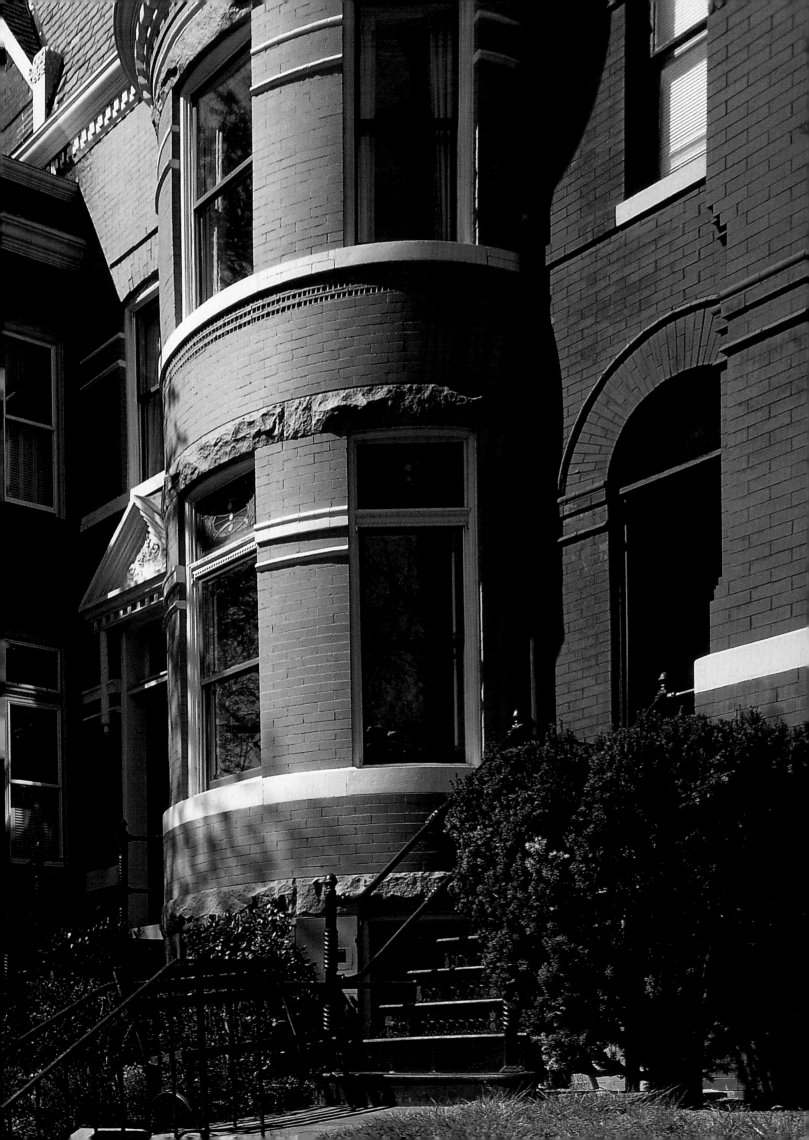

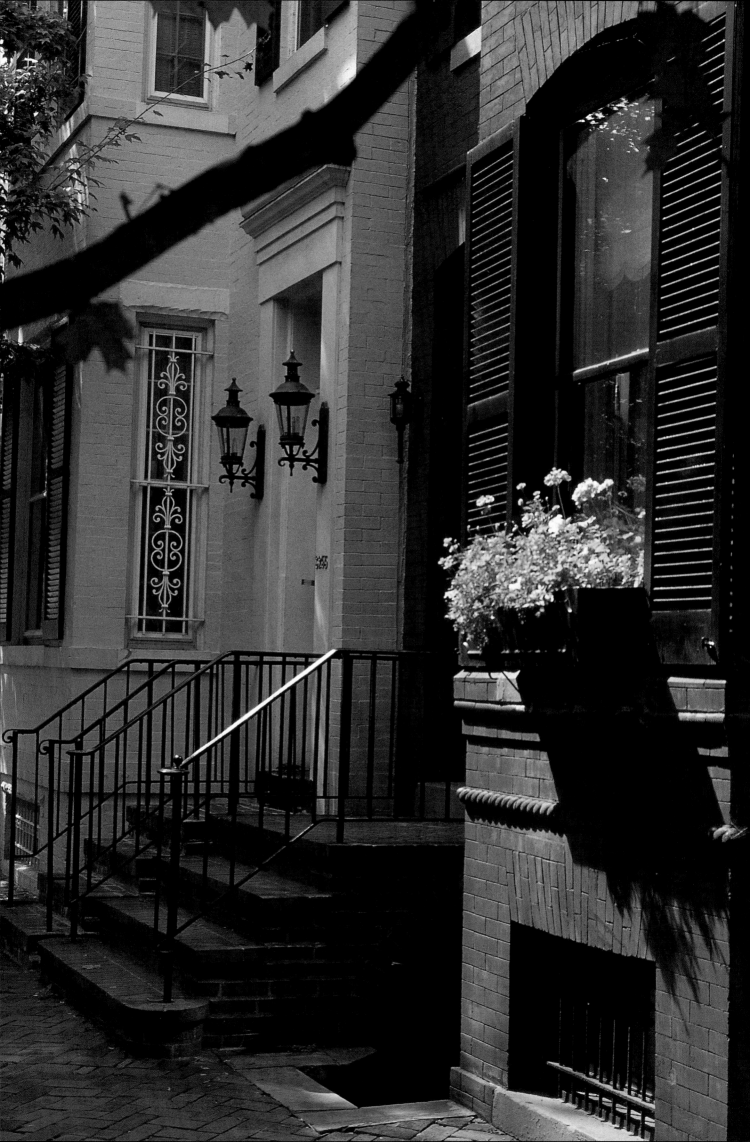

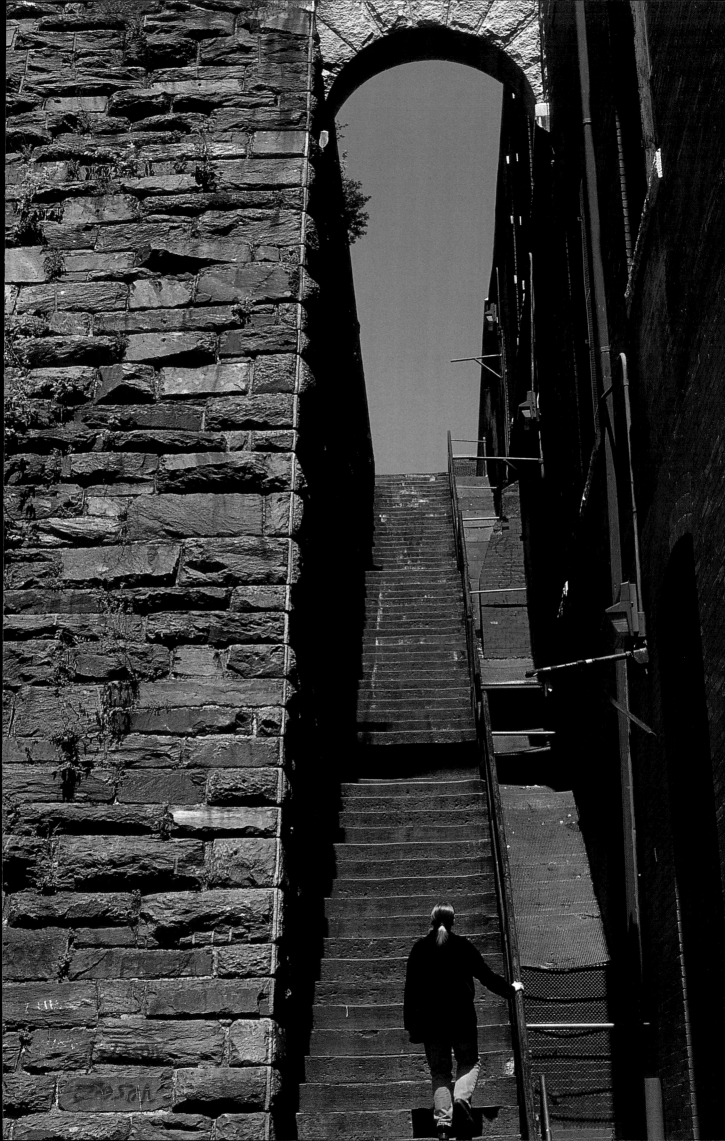

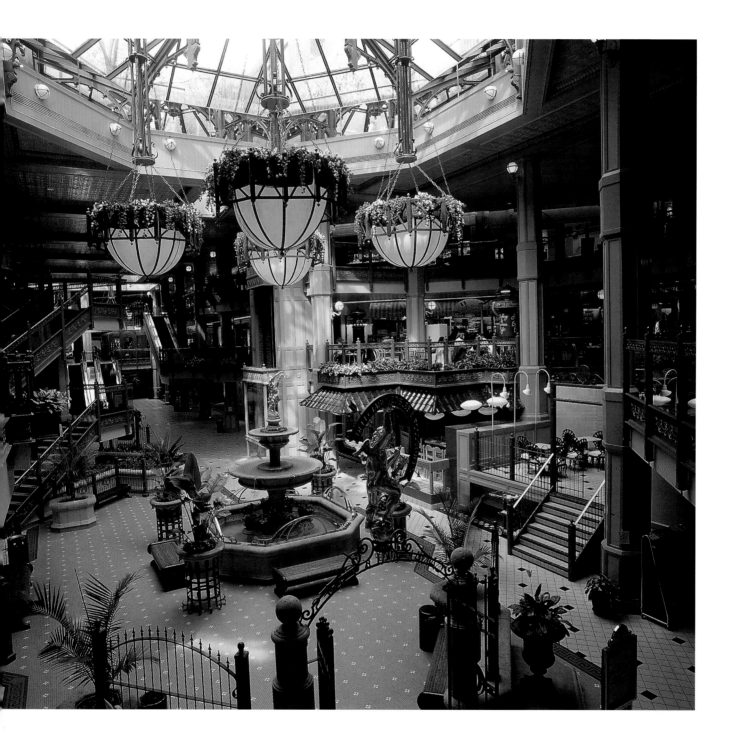

118 **(previous overleaf)** Row Houses and *The Exorcist* Steps. Made famous by the movie *The Exorcist*, these 75 steps are located near 36th Street and Prospect Street NW.

(top) Georgetown Shopping Plaza. **(right)** Georgetown Shopping Development.

(overleaf) Trompe l'oeil mural evocatively represents 18th century Georgetown.

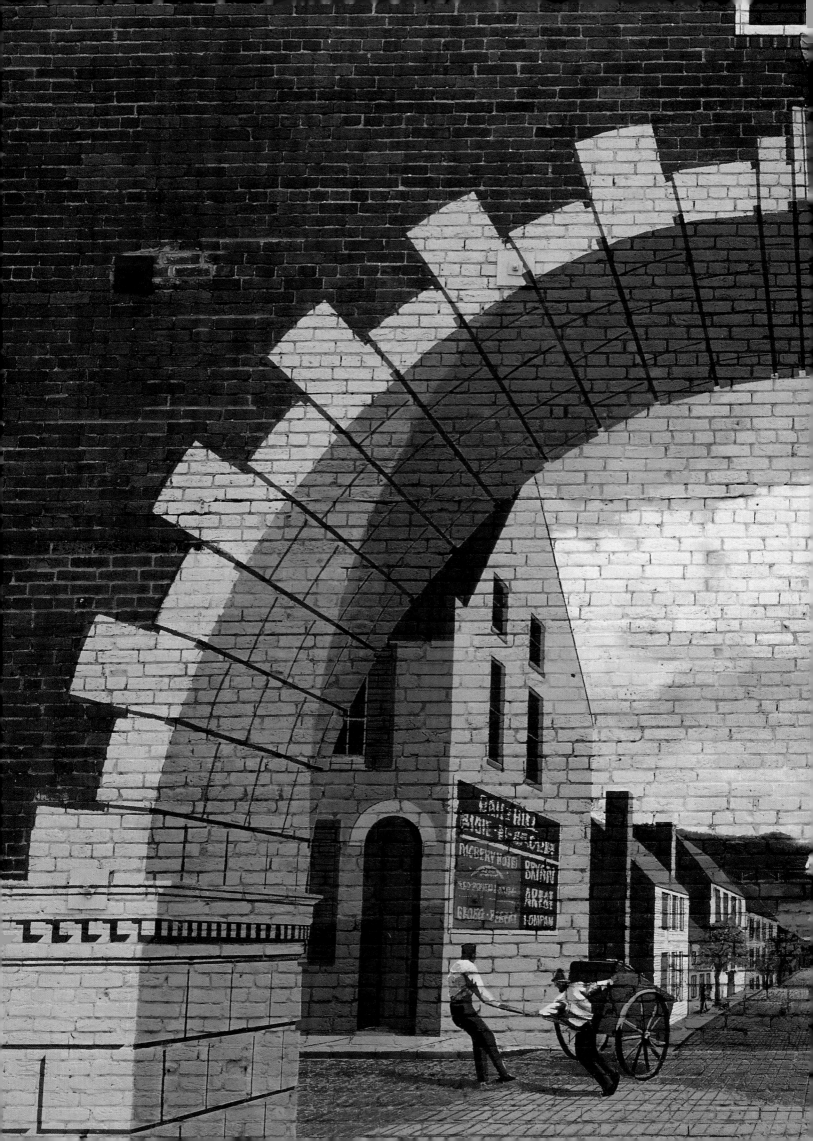

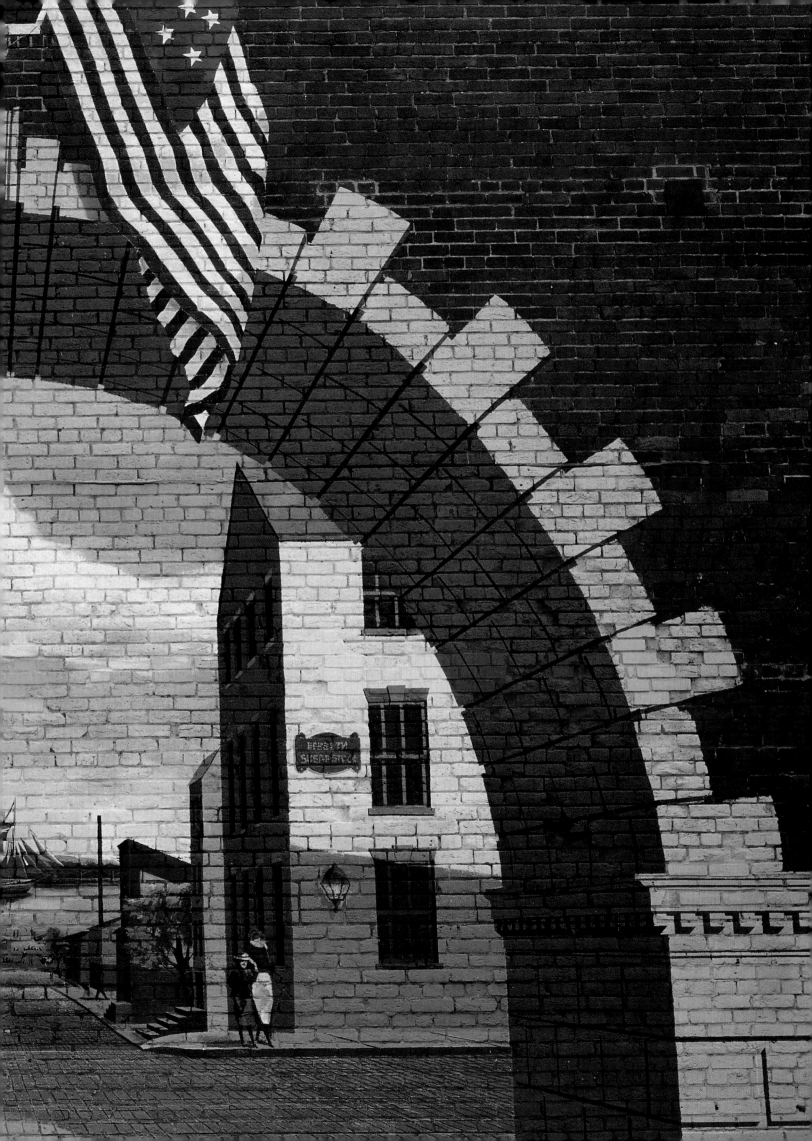

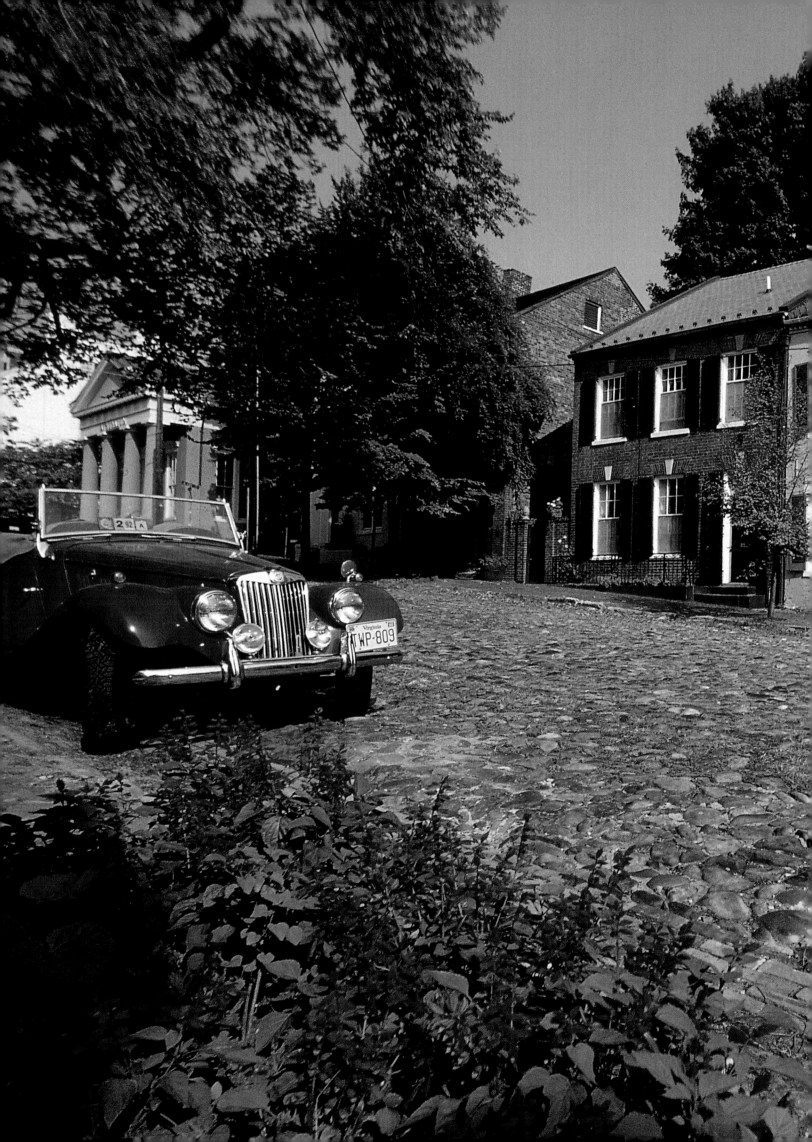

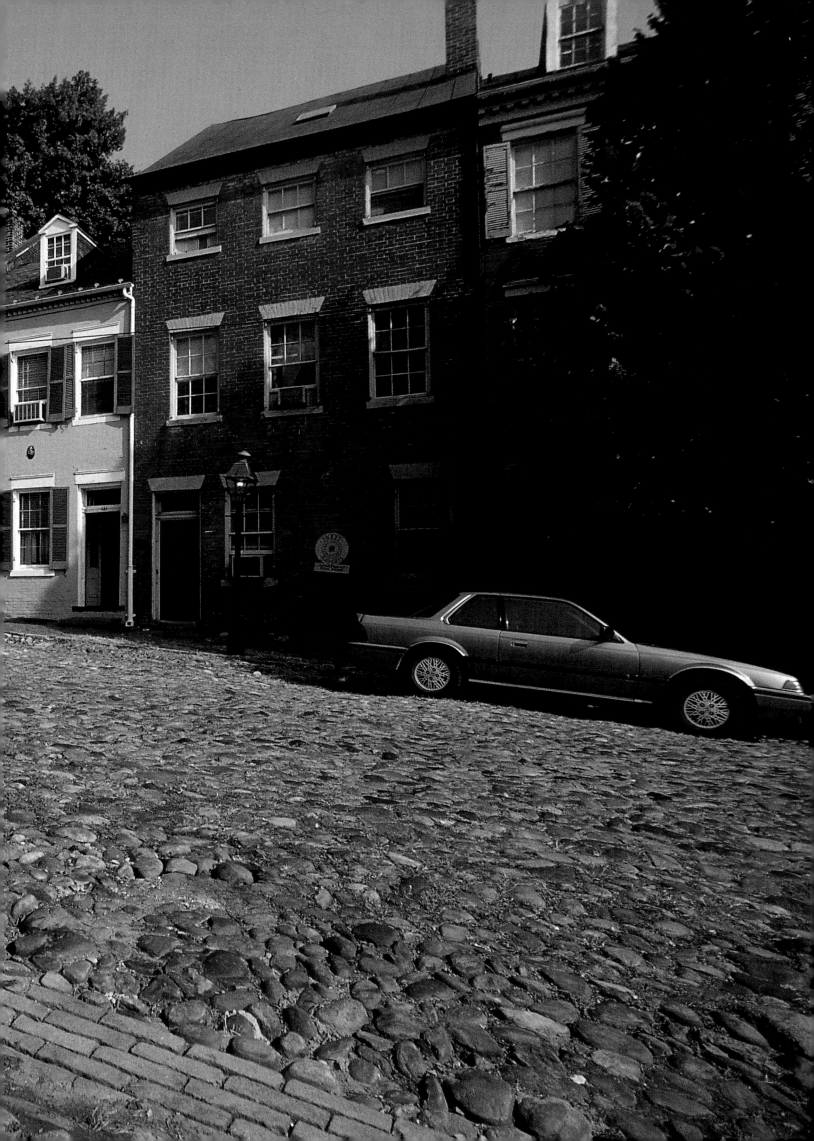

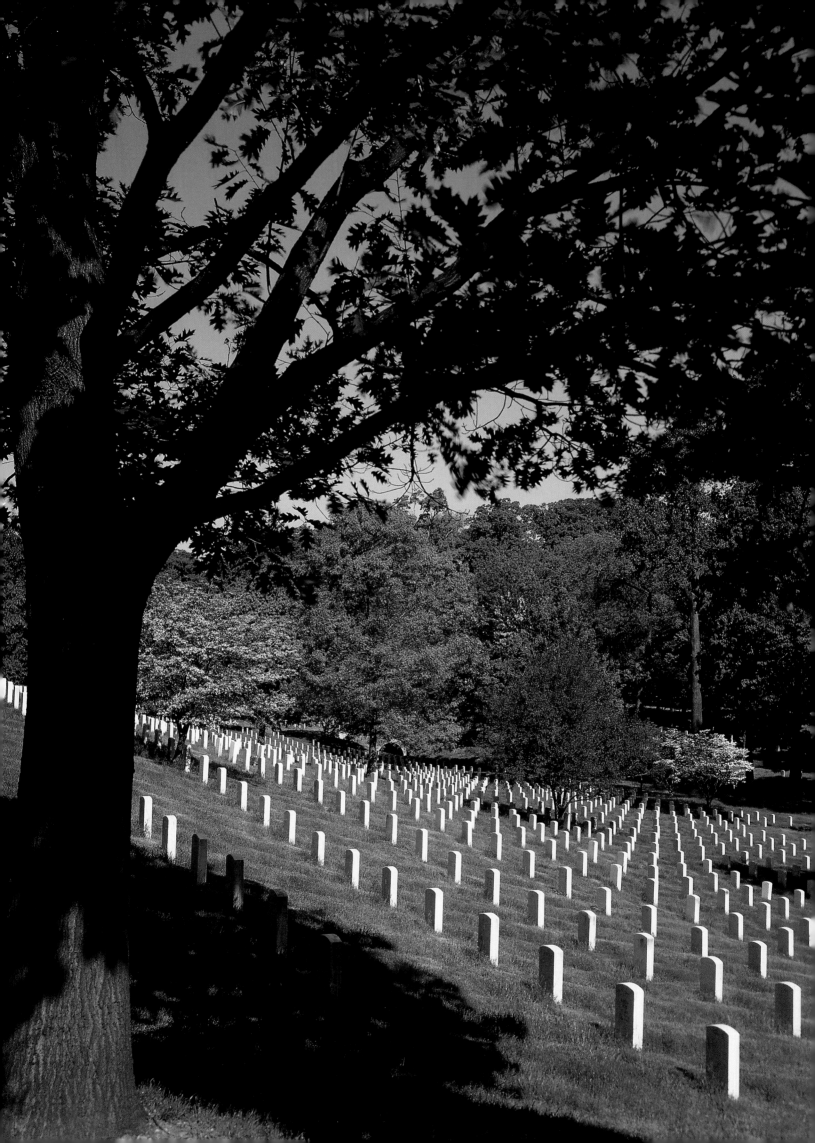

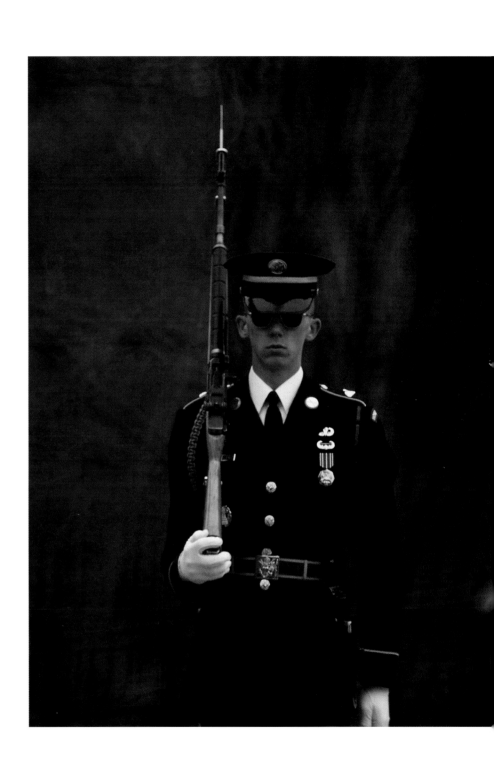

125 **(previous overleaf)** Captain's Row. Captain's Row in nearby Alexandria, Virginia, contains homes built by many of the city's sea captains. The cobblestones are believed to have been laid during the Revolution by Hessian prisoners of war.

 (left and overleaf) The Arlington National Cemetery. Two hundred thousand graves are spread over Arlington National Cemetery's 612 acres. Approximately fifteen funerals are held at the cemetery every day to honor military veterans. It is estimated that the cemetery will be full by the year 2020. **(above)** Soldier in front of The Tomb of the Unknown Soldier.

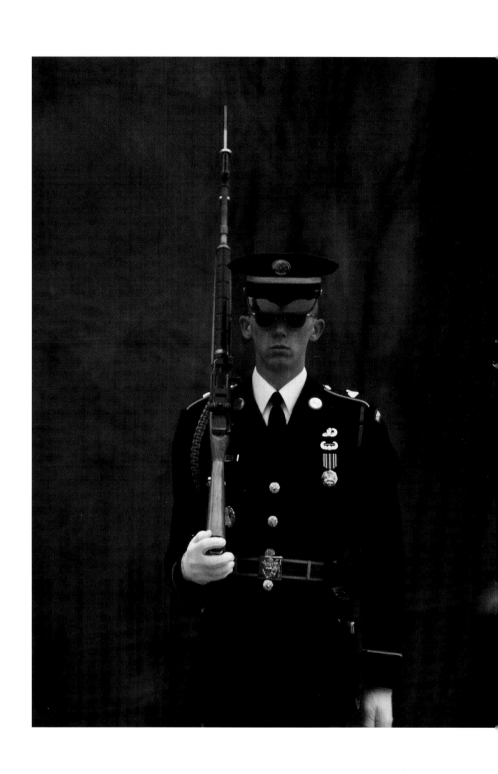

125 **(previous overleaf)** Captain's Row. Captain's Row in nearby Alexandria, Virginia, contains homes built by many of the city's sea captains. The cobblestones are believed to have been laid during the Revolution by Hessian prisoners of war.

(left and overleaf) The Arlington National Cemetery. Two hundred thousand graves are spread over Arlington National Cemetery's 612 acres. Approximately fifteen funerals are held at the cemetery every day to honor military veterans. It is estimated that the cemetery will be full by the year 2020. **(above)** Soldier in front of The Tomb of the Unknown Soldier.

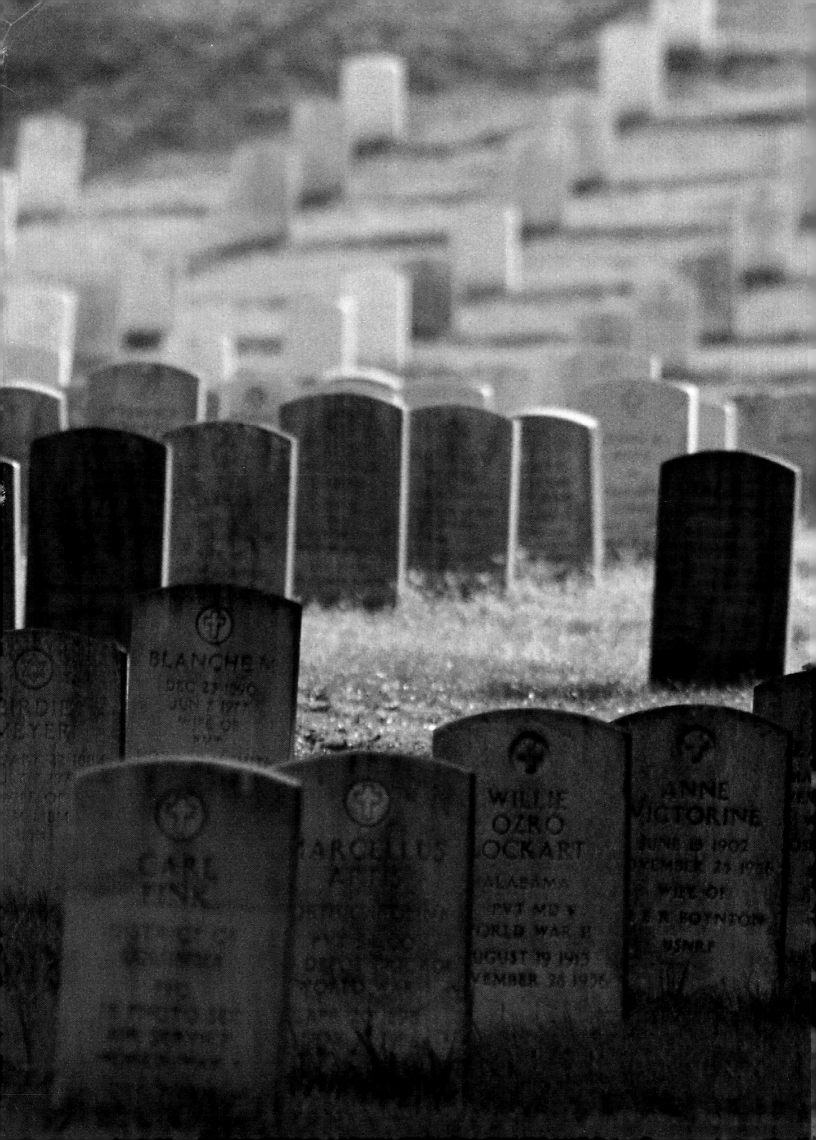

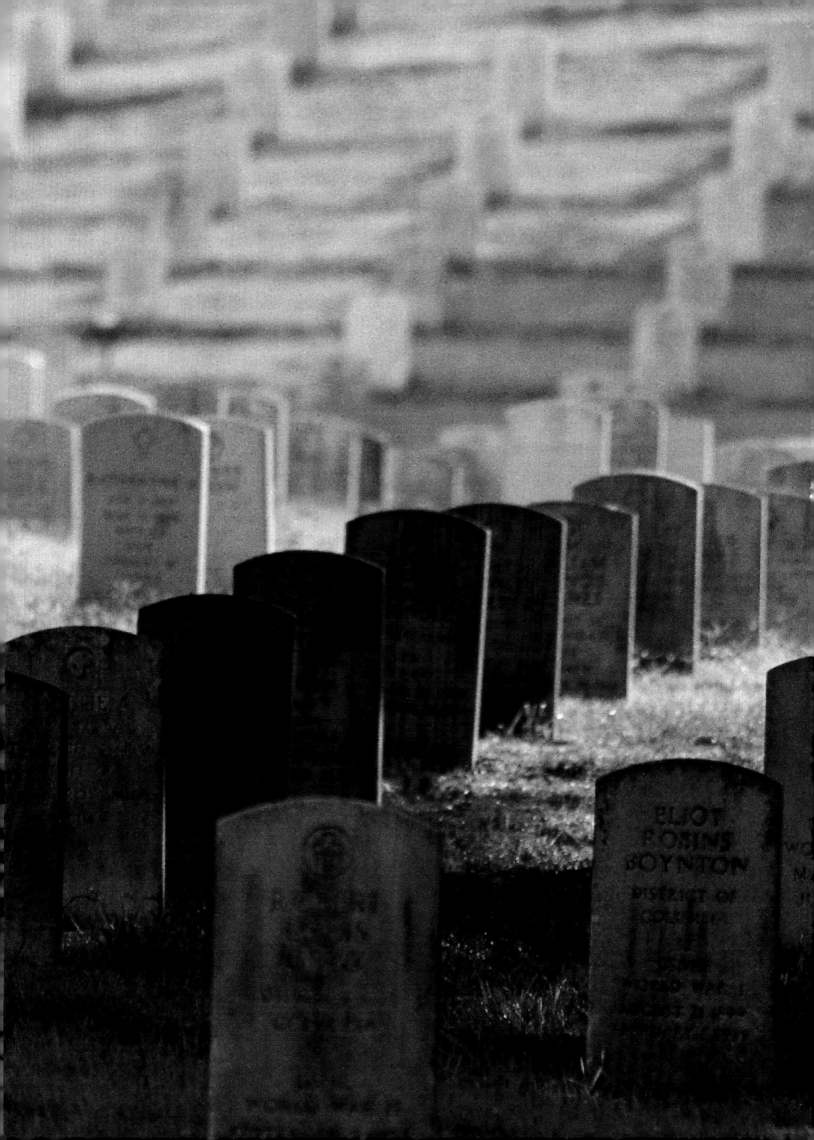

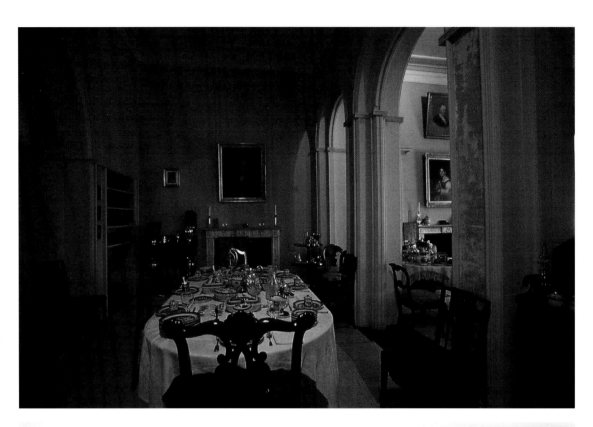

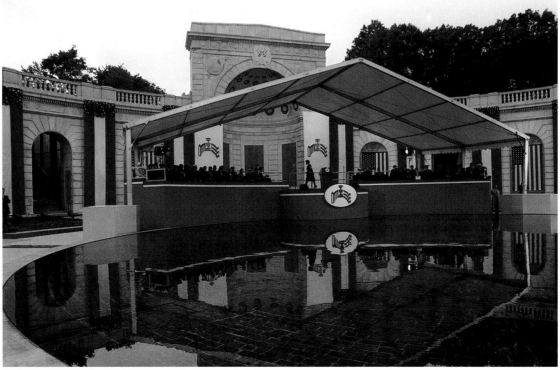

128 **(top)** Arlington House, interior. **(bottom)** The stage is reflected in the Women's Memorial pool during the dedication ceremony Saturday, Oct, 18th, 1997, at Arlington National Cemetery in Arlington.